On a Friday Noon

MEDITATIONS UNDER THE CROSS

On a
Friday Noon

Hans-Ruedi Weber

LONDON
SPCK

First published 1979
Joint publication by the World Council of Churches, Eerdmans and SPCK.
This edition published through special arrangements with the
World Council of Churches and Eerdmans by SPCK, Holy Trinity Church, Marylebone Road, London NW1 4DU.

© Copyright 1979 by the World Council of Churches, Geneva
Cover design and lay-out: Paul May, London
Printed and bound in Great Britain at William Clowes & Sons Limited, Beccles and London.

ISBN: 0 281 03703 5

Table of Contents

Introduction

It happened on a Friday noon. The scene was just outside the ancient walls of Jerusalem and the date, probably the 7th of April in the year 30 A.D. Seen through the eyes of the people then living in Palestine, nothing out of the ordinary occurred: three men were executed by crucifixion. One was a rabbi from Galilee, the other two Jewish rebels, probably suspected members of the growing resistance movement against the Roman occupation of their promised land. So many crucifixions took place at that time that only a few people went to see the sordid spectacle.

Usually the agony of those crucified was long, sometimes as much as two or three days and nights. Yet on that Friday noon one of the victims died astonishingly quickly: Jeshua ben Joseph, the teacher from Nazareth. This death has been remembered ever since by an increasing number of children, women and men in all centuries and cultures. Theologians have written many books about it. Men and women of great prayer have addressed ardent confessions, petitions and praise to this crucified Christ. Yet poets, musicians, painters and sculptors have also meditated deeply on Jesus' crucifixion and explored its many-faceted meaning. Such artistic interpretations of the cross serve better than sermons to help us see the true significance of what happened that Friday noon.

The first part of this book consists of thirty-three reproductions which show how artists of different centuries and cultures understood the mystery of Christ's death. A meditative text characteristic of the artist's time and place accompanies each reproduction. The second part makes a journey across frontiers of centuries and cultures, following the main lines of development set by the artistic interpretations of the cross.

In this way may readers be led from the knowledge of Christ crucified to the praise of him who through his death overcame death.

Hans-Ruedi Weber

Part One *Meditations under the Cross*

"This doctrine of the cross is sheer folly to those on their way to ruin, but to us who are on the way to salvation it is the power of God. Scripture says: 'I will destroy the wisdom of the wise, and bring to nothing the cleverness of the clever.' Where is your wise man now, your man of learning, or your subtle debater – limited, all of them, to this passing age? God has made the wisdom of this world look foolish. As God in his wisdom ordained, the world failed to find him by its wisdom, and he chose to save those who have faith by the folly of the Gospel. Jews call for miracles, Greeks look for wisdom; but we proclaim Christ – yes, Christ nailed to the cross; and though this is a stumbling-block to Jews and folly to Greeks, yet to those who have heard his call, Jews and Greeks alike, he is the power of God and the wisdom of God."

I Corinthians 1:18–24

" 'The hour has come for the Son of Man to be glorified. In truth, in very truth I tell you, a grain of wheat remains a solitary grain unless it falls into the ground and dies; but if it dies, it bears a rich harvest. The man who loves himself is lost, but he who hates himself in this world will be kept safe for eternal life. If anyone serves me, he must follow me; where I am, my servant will be. Whoever serves me will be honoured by my Father. Now my soul is in turmoil, and what am I to say? Father, save me from this hour. No, it was for this that I came to this hour. Father, glorify thy name.' A voice sounded from heaven: 'I have glorified it, and I will glorify it again.' The crowd standing by said it was thunder, while others said: 'An angel has spoken to him.' Jesus replied: 'This voice spoke for your sake, not mine. Now is the hour of judgment for this world; now shall the prince of this world be driven out. And I shall draw all men to myself, when I am lifted up from the earth.' This he said to indicate the kind of death he was to die."

John 12:23–33

God has reigned from a tree

The standards of the King appear,
the mystery of the cross shines out in glory,
the cross on which life suffered death
and by that death gave back life to us.

His side, wounded by the spear's cruel point,
poured out water and blood
to wash away the stains of our sins.

The words of David's true prophetic song were
 fulfilled,
in which he announced to the nations:
"God has reigned from a tree."

Tree of dazzling beauty,
adorned with the purple of the King's blood,
and chosen from a stock
worthy to bear limbs so sacred.

How favoured the tree
on whose branches hung the ransom of the world;
it was made a balance on which his body was
 weighed,
and bore away the prey that hell had claimed.

Hail, cross, our only hope!
In this season of passiontide
give an increase of grace to the good
and wipe out the sins of the guilty.

Let every spirit praise you,
fount of salvation, Holy Trinity.
On those to whom you have generously given the
 victory of the cross,
bestow the reward also. Amen.

Passion Hymn by Venantius Fortunatus
(6th century)

Plate I
"The cross of transfiguration." Apsis mosaic of
Sant'Apollinare de Classe, Ravenna (6th century).

3

Plate I

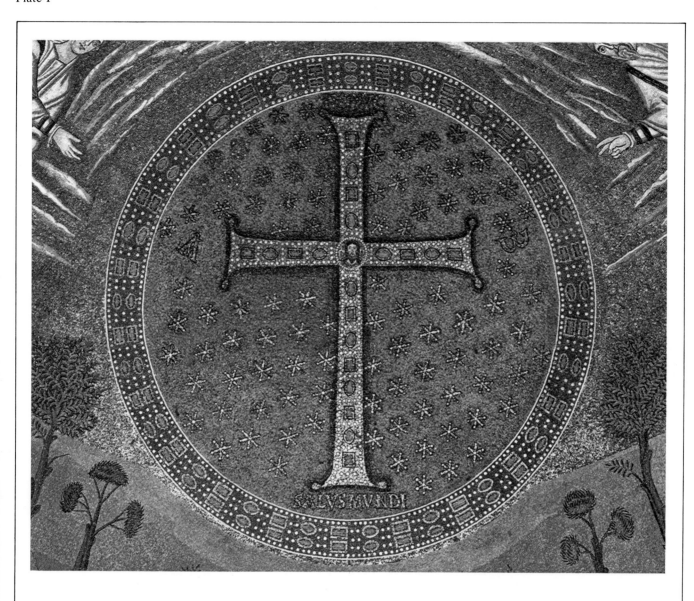

Desperation and obedience

"When Judas the traitor saw that Jesus had been condemned, he was seized with remorse, and returned the thirty silver pieces to the chief priests and elders. 'I have sinned,' he said; 'I have brought an innocent man to his death.' But they said: 'What is that to us? See to that yourself.' So he threw the money down in the temple and left them, and went and hanged himself."

Matthew 27:3–5

"Near the cross where Jesus hung stood his mother, with her sister, Mary wife of Clopas, and Mary of Magdala. Jesus saw his mother, with the disciple whom he loved standing beside her. He said to her: 'Mother, there is your son'; and to the disciple: 'There is your mother'; and from that moment the disciple took her into his home.

"After that, Jesus, aware that all had now come to its appointed end, said in fulfilment of scripture: 'I thirst.' A jar stood there full of sour wine; so they soaked a sponge with the wine, fixed it on a javelin, and held it up to his lips. Having received the wine, he said: 'It is accomplished!' He bowed his head and gave up his spirit.

"Because it was the eve of Passover, the Jews were anxious that the bodies should not remain on the cross for the coming sabbath, since that sabbath was a day of great solemnity; so they requested Pilate to have the legs broken and the bodies taken down. The soldiers accordingly came to the first of his fellow-victims and to the second, and broke their legs; but when they came to Jesus, they found that he was already dead, so they did not break his legs. But one of the soldiers stabbed his side with a lance, and at once there was a flow of blood and water. This is vouched for by an eye witness, whose evidence is to be trusted. He knows that he speaks the truth, so that you too may believe."

John 19:25–35

Plate II
(a) Ivory tablet on the crucifixion from northern Italy (A.D. 420–430)
(b) Crucifixion scene on the wooden doors of Santa Sabina, Rome (around 432).

Plate II

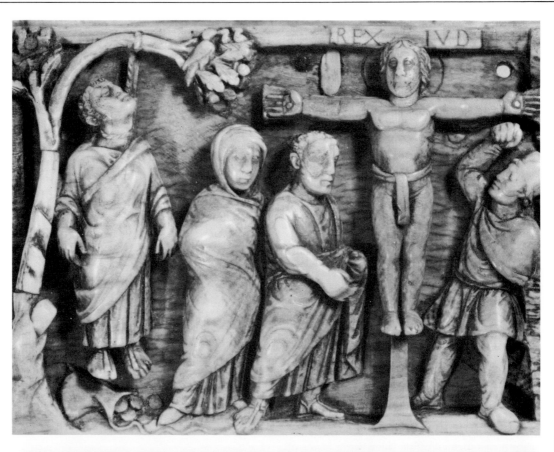

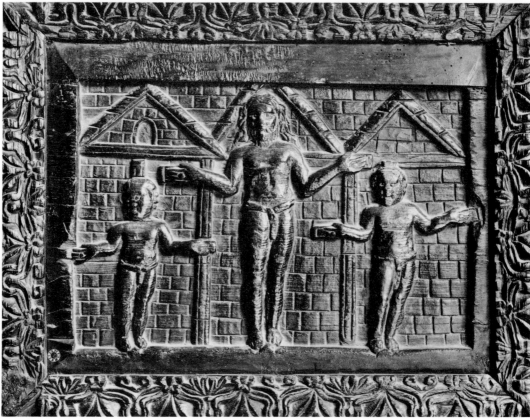

The events at the turn of the ages

"The hour of the crucifixion was nine in the morning, and the inscription giving the charge against him read: 'The king of the Jews.' Two bandits were crucified with him, one on his right and the other on his left.

"The passers-by hurled abuse at him: 'Aha!' they cried, wagging their heads, 'you would pull the temple down, would you, and build it in three days? Come down from the cross and save yourself!' So too the chief priests and lawyers jested with one another: 'He saved others,' they said, 'but he cannot save himself. Let the Messiah, the king of Israel, come down now from the cross. If we see that, we shall believe.' Even those who were crucified with him taunted him.

"At midday a darkness fell over the whole land, which lasted till three in the afternoon; and at three Jesus cried aloud: *Eli, Eli, lema sabachthani*?', which means: 'My God, my God, why hast thou forsaken me?' Some of the bystanders, on hearing this, said: 'Hark, he is calling Elijah.' A man ran and soaked a sponge in sour wine and held it to his lips on the end of a cane. 'Let us see', he said, 'if Elijah will come to take him down.' Then Jesus gave a loud cry and died. And the curtain of the temple was torn in two from top to bottom. And when the centurion who was standing opposite him saw how he died, he said: 'Truly this man was a son of God.'

"A number of women were also present, watching from a distance. Among them were Mary of Magdala, Mary the mother of James the younger and of Joseph, and Salome, who had all followed him and waited on him when he was in Galilee, and there were several others who had come up to Jerusalem with him."

Mark 15:25–41

"The sabbath was over, and it was about daybreak on Sunday, when Mary of Magdala and the other Mary came to look at the grave. Suddenly there was a violent earthquake; an angel of the Lord descended from heaven; he came to the stone and rolled it away, and sat himself down on it. His face shone like lightning; his garments were white as snow. At the sight of him the guards shook with fear and lay like the dead.

"The angel then addressed the women: 'You', he said, 'have nothing to fear. I know you are looking for Jesus who was crucified. He is not here; he has been raised again, as he said he would be. Come and see the place where he was laid, and then go quickly and tell his disciples: "He has been raised from the dead and is going on before you into Galilee; there you will see him." That is what I had to tell you.'

"They hurried away from the tomb in awe and great joy, and ran to tell the disciples. Suddenly Jesus was there in their path. He gave them his greeting, and they came up and clasped his feet, falling prostrate before him. Then Jesus said to them: 'Do not be afraid. Go and take word to my brothers that they are to leave for Galilee. They will see me there.'"

Matthew 28:1–10

Plate III
Crucifixion and resurrection scene, illustration in Codex Rabula, fol 13r, from Zagbar, East Syria (A.D. 586).

Plate III

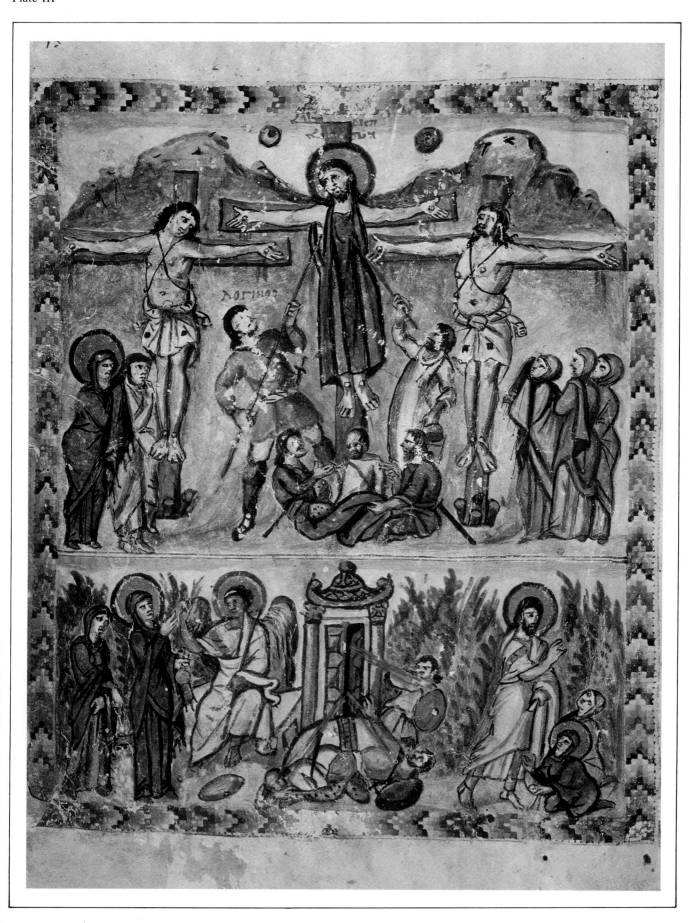

Plate III

Media Vita

In life still death is here,
There is one common doom.
Oh, how shall we prepare
For a believer's tomb?
Peace is of thee alone –
Thou only canst atone
The sins we grieve, and from thy wrath
Make us a path
To heaven.
O holy Lord and God,
Eternal Christ of God,
Hear thou our faltering breath,
Spare us from endless death,
Kyrie eleison.

In death the jaws of hell
Against our spirits gape.
Lord God, wilt thou not save,
And grant us swift escape?
'Tis thou, dear Lord, didst win
The conquest of our sin,
And pity for our souls obtain;
Else hope were vain
Of heaven.
O holy Lord and God,
Eternal Christ of God,
Hear thou our bitter cry,
And save us e'er we die!
Kyrie eleison.

In hell's dark midst, our sin
Would drive us to despair.
Oh, whither shall we fly?
Where is our refuge, where?
Thy blood, O Christ, alone
Can for our sin atone.
'Tis in the holy rood to give
The grace to live
In heaven.
O holy Lord and God,
Eternal Christ of God,
Grant from thy faith we all
May never, never fall!
Kyrie eleison.

Attributed to
Notker Balbulus (840–912)

Plate IV
Carolingian ivory relief with crucifixion, cover of pericope-
book of Henry II (9th century).

9

Plate IV

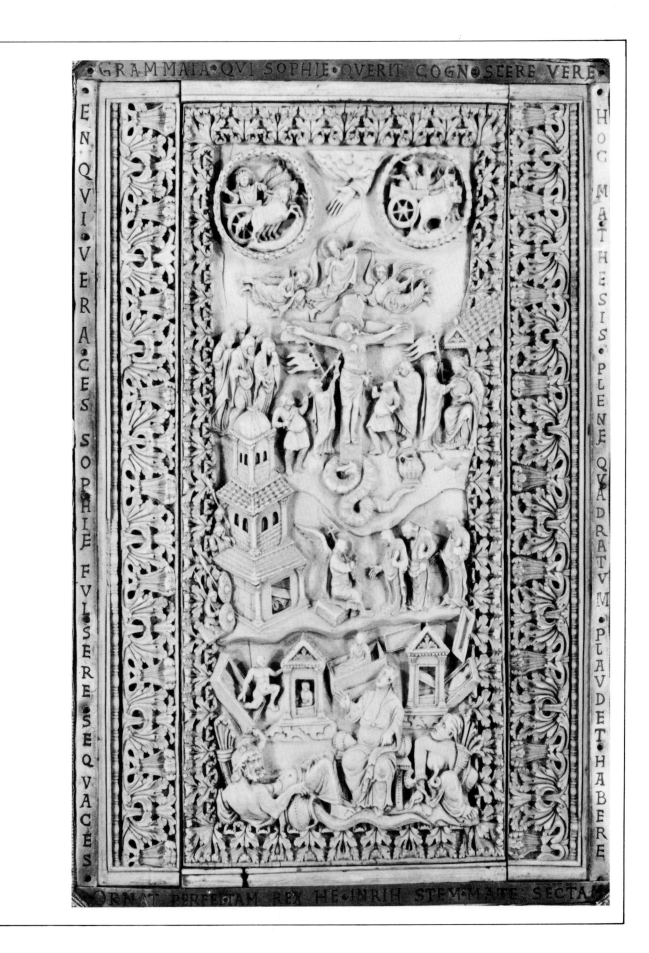

The priest and the victim

"This is the truth of the gospel, that the true disciples of Christ crucified should follow him with the cross. A great example has been shown, a great mystery has been declared; the Son of God willingly (for he was offered up because he himself willed it) mounted the cross as a criminal, leaving to us, as it is written, an example, that we should follow his footsteps. Blessed then is the man, who becomes a sharer in this passion and this shame. For there is something wonderful there concealed; for the foolishness of God is wiser than men, and the weakness of God is stronger than men. Strangely is immeasurable wisdom discerned in foolishness, and in weakness incomparable strength. Thus are hidden there all choice consolations, the secrets of salvation; but they are difficult in order that they may be precious; they are veiled in order that they may be merited by few; merited indeed by few, since they are too wonderful. Therefore let us patiently bear all adversities for truth's sake, that we may be sharers in the Lord's passions; for if we suffer together with him, together we shall reign."

Columban,
Irish missionary to the Franks
(c. 530–615)

Come, all saints,
take Christ's body,
drink the holy,
the redeeming blood.

Giver of salvation,
Christ, God's son,
the world he saved
through cross and blood.

For each and all
has the Lord been slain.
In him the priest
appears and the victim.

Alpha and Omega
is he, Christ the Lord,
who came and will come
to judge all people.

From an early
medieval Irish eucharistic hymn

Plate V
Frankish gravestone from Moselkern near Cochem, Germany (7th century).

The Suffering Servant

"Behold, my servant shall prosper,
he shall be lifted up, exalted to the heights.
Time was when many were aghast at you, my people;
so now many nations recoil at sight of him,
and kings curl their lips in disgust.
For they see what they had never been told
and things unheard before fill their thoughts.
Who could have believed what we have heard,
and to whom has the power of the Lord been revealed?
He grew up before the Lord like a young plant
whose roots are in parched ground;
he had no beauty, no majesty to draw our eyes,
no grace to make us delight in him;
his form, disfigured, lost all the likeness of a man,
his beauty changed beyond human semblance.
He was despised, he shrank from the sight of men,
tormented and humbled by suffering;
we despised him, we held him of no account,
a thing from which men turn away their eyes.
Yet on himself he bore our sufferings,
our torments he endured,
while we counted him smitten by God,
struck down by disease and misery;
but he was pierced for our transgressions,
tortured for our iniquities;
the chastisement he bore is health for us
and by his scourging we are healed.
We had all strayed like sheep,
each of us had gone his own way;
but the Lord laid upon him the guilt of us all.
He was afflicted, he submitted to be struck down
and did not open his mouth;
he was led like a sheep to the slaughter,
like a ewe that is dumb before the shearers.
Without protection, without justice, he was taken away;
and who gave a thought to his fate,
how he was cut off from the world of living men,
stricken to the death for my people's transgression?
He was assigned a grave with the wicked,
a burial-place among the refuse of mankind,
though he had done no violence
and spoken no word of treachery.
Yet the Lord took thought for his tortured servant
and healed him who had made himself a sacrifice for sin;
so shall he enjoy long life and see his children's children,
and in his hand the Lord's cause shall prosper.
After all his pains he shall be bathed in light,
after his disgrace he shall be fully vindicated;
so shall he, my servant, vindicate many,
himself bearing the penalty of their guilt.
Therefore I will allot him a portion with the great,
and he shall share the spoil with the mighty,
because he exposed himself to face death
and was reckoned among transgressors,
because he bore the sin of many
and interceded for their transgressions."

Isaiah 52:13–53:12

Plate VI
Gero-Cross in the Cathedral of Cologne, oakwood
sculpture (around 965).

Plate VI

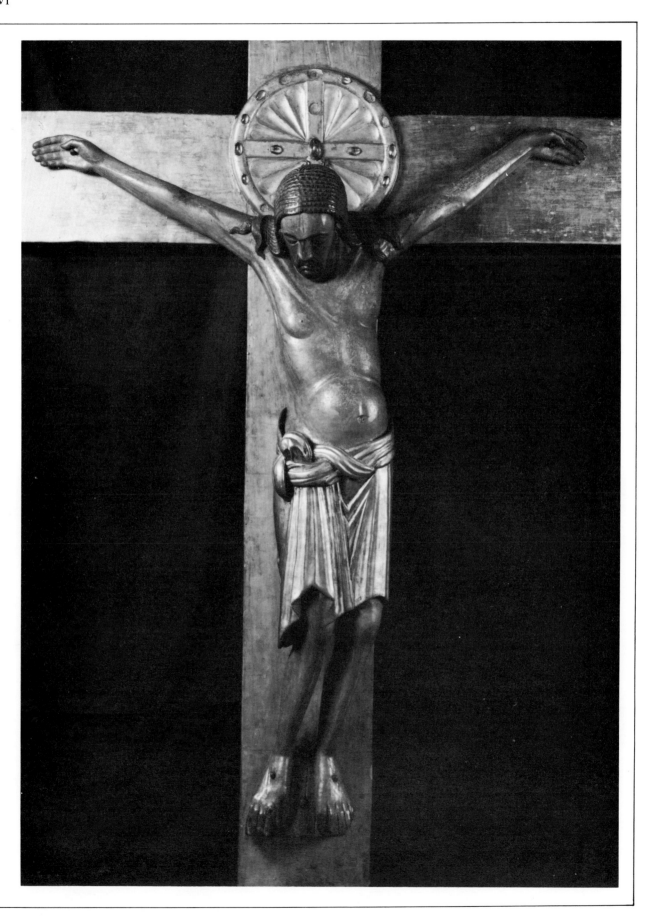

14

I see you crucified and I call you King

"The crucified of the Orient never shows forth the realism of an exhausted and dead body nor the distress of agony. Having died and come to peace, he has nothing lost of his royal nobility and he maintains his majesty, as Saint Chrysostom once said: 'I see you crucified and I call you King . . .'

"In its vertical pole the icon of the crucifixion manifests the descent and the ascent of the Word. 'Christ on the Cross', said Jacques de Saroug, 'stood on earth as on a ladder with many steps.' The cross is 'the tree of life, planted on Calvary', the place of the great 'cosmic combat'. The Acts of Andrew state it expressively: 'Part of the cross is planted in the earth so as to reunite the things of this earth and in hell with the things of heaven.' In the icon the cross-pole penetrates therefore into the black cavern where the skull of Adam lies, Golgotha being the 'Place of the Skull'. This symbolic detail shows the head of the first Adam, and with him the whole of humanity, being cleansed by the blood of Christ.

"The architectural background shows the walls of Jerusalem. Christ has to suffer outside the walls of the city and the faithful must follow him, 'for here we have no permanent home'. Above, the clear background of the skies manifests the cosmic effect of the cross which cleansed the airs from demonic powers, as Saint Athanasius and Saint Chrysostom taught.

"The Saviour on the cross is not simply a dead Christ, but the Kyrios (Lord), the Master of his own death and the Lord of his life. He has not changed in the course of his Passion. He remains the Word, the eternal Life which gives itself up to death and transcends death. 'When you were crucified, O Christ, the whole creation took horror at this spectacle and the foundations of the earth trembled before your power.'

"The God-Man appeared in his double and unseparable dimension: with God above, with humanity below. Angels glide at the top of the cross, in heaven, while the persons standing under the cross, a holy woman and the centurion Longinus, figure humanity.

"As one contemplates the icon one is reminded of the beautiful reflection by Nicolas Cabasilas: 'It is with a view to Christ that the human heart was created, an immense jewel-case, vast enough to contain God himself . . . The eye was created for the light, the ear for the sounds, all things for their own purpose, and the longing of the soul for reaching up towards Christ.'"

Paul Evdokimov

Plate VII
Icon of crucifixion, school of Master Dionisi, Moscow (around 1500).

Plate VII

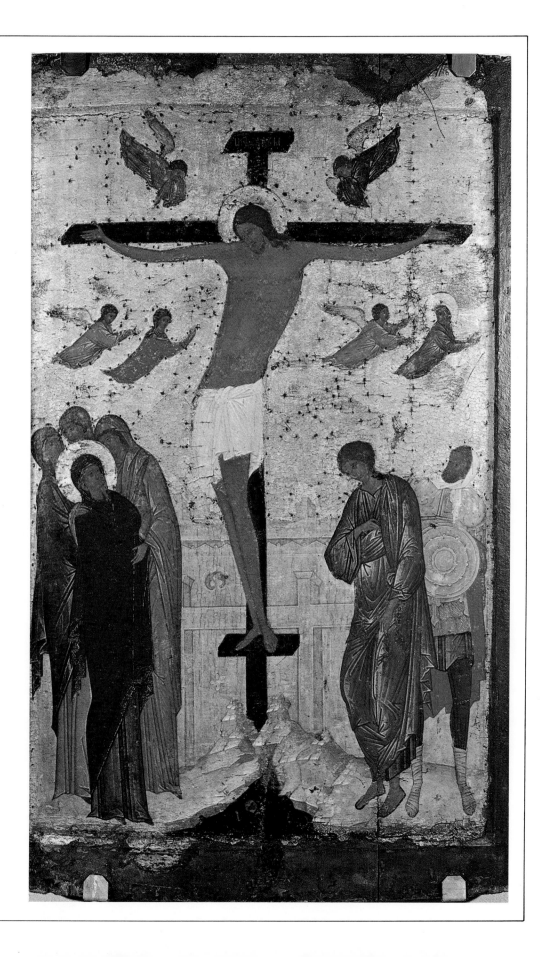

15

The throne of love

The following affirmation of faith was written in the early 12th century by Rupert, the Abbot of Deutz. He once told how in a dream he saw high up in the church nave the Romanesque Christ on the cross who looked at him with wide open eyes. Rupert was lifted up so that he could tenderly embrace the crucified Lord.

"We venerate the cross as a safeguard of faith, as the strengthening of hope and the throne of love. It is the sign of mercy, the proof of forgiveness, the vehicle of grace and the banner of peace. We venerate the cross, because it has broken down our pride, shattered our envy, redeemed our sin and atoned for our punishment.

"The cross of Christ is the door to heaven, the key to paradise, the downfall of the devil, the uplifting of mankind, the consolation of our imprisonment, the prize for our freedom. The cross was the hope of the patriarchs, the promise of the prophets, the triumph of kings and the ministry of priests. Tyrants are convicted by the cross and the mighty ones defeated, it lifts up the miserable and honours the poor. The cross is the end of darkness, the spreading of light, the flight of death, the ship of life and the kingdom of salvation.

"Whatever we accomplish for God, whatever we succeed and hope for, is the fruit of our veneration of the cross. By the cross Christ draws everything to him. It is the kingdom of the Father, the sceptre of the Son and the seal of the Holy Spirit, a witness to the total Trinity."

Rupert, Abbot of Deutz

Plate VIII
Catalan crucified Christ of Romanesque period.

Plate VIII

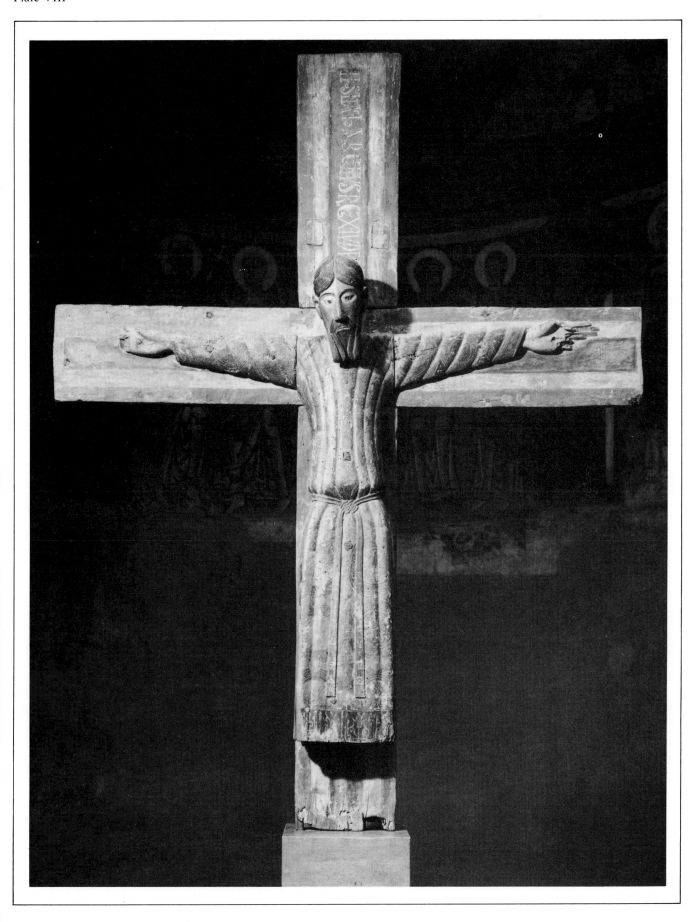

The agony

Saint Bridget of Sweden, who died in 1373, writes in her "Revelations" how during a vision, Mary herself, the mother of Christ, described the death of her son. This vision reflects the Gothic Christ.

"When my son saw me under the cross and noticed his mourning friends he cried out to his heavenly father, with a loud and wailing voice: 'My father, why have you forsaken me?' It was as if he wanted to say: 'Nobody except you can have mercy upon me.'

"The look in his eye seemed to us already half faded away, his teeth smeared with blood, his face cruelly distorted, his mouth open and his saliva mingled with blood. His body was hollow and dried out as if he had no longer any entrails. As all his blood had been lost, he turned pale. His members were convulsively stretched out, hair and beard encrusted with blood. When finally death came near, the heart of my son broke under the violence of pain. His body contracted, once again his head lifted and then fell forward on his breast. Yet his mouth remained open so that his tongue, smeared with blood, could be seen. His hands spasmodically gripped the nails and then released their grip. Arms and legs lost their tension and his body hung heavily on the cross."

Saint Bridget of Sweden

Plate IX
"The Devout Christ of Perpignan", Gothic wood sculpture, Chapel of St John the Baptist Cathedral in Perpignan, France.

Plate IX

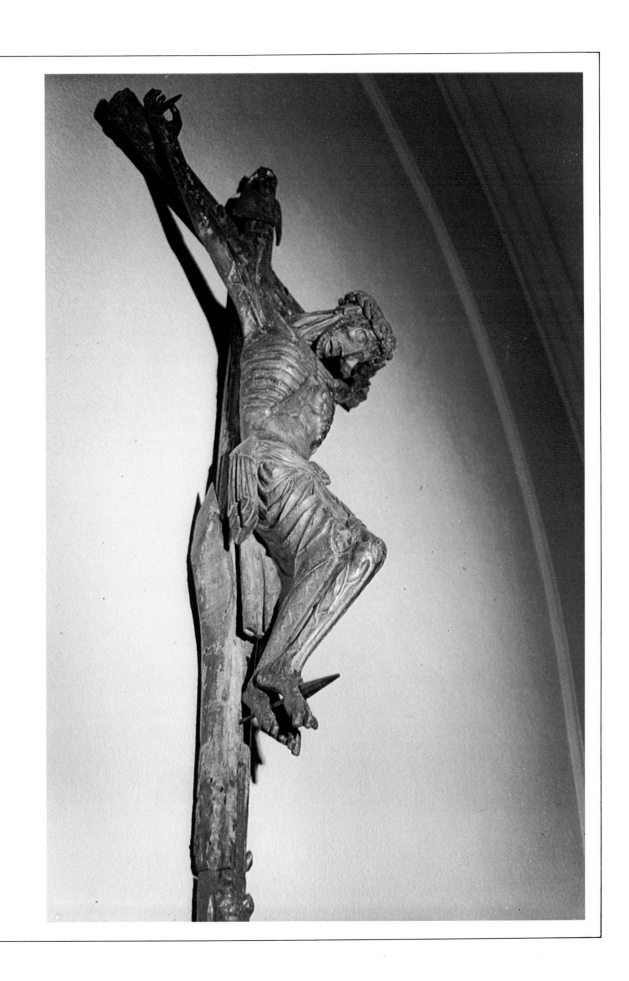

The passion play

*The passion plays which developed in the late
Middle Ages enact the whole of history as one great
battle between God and Satan for the human soul.
In a crucifixion scene of some English cycles called
"Corpus Christi" the torturers*

". . . converse as if they were servants arming and
horsing a great lord before he rides to joust in battle.
They find the joke very funny, for the figure of Christ
in these circumstances accords ill with the aristocratic
metaphor . . . They have great trouble in getting him
'horsed', and contests of strength are necessary to get
the cross into place.

"In earlier centuries, when Christ was customarily
shown as victorious *on* the cross, the crucifixion was
chiefly understood as a theological rather than human
event. By the time of the cycles, the dying and the
victory were conceived separately: victory was
postponed until Christ harrowed hell, and a
traditional statement of his triumph there was as a
knightly combat in which he jousts with Satan for
man's soul . . . The irony centres on the fact that
the real battle is to be fought not against the
executioners – they are, though they do not know it,
Christ's armourers and accomplices – but against the
devil. The executioners think the action is over when
Christ dies, but the audience knows that it is really
just beginning."

*A reference to this scene of the passion play is
found in a 14th century sermon where Christ is
described in the following way:*
"For a horse he had the cross upon which he hung;
for a shield he offered his side,
and he advanced against the enemy so,
with a spear not in his hand
but sticking in his side."

V. A. Kolve

Plate X
"The Passion of Jesus Christ", painting by the Flemish
artist Hans Memling (1470).

Plate X

The death of Death

Miguel de Unamuno (1864–1936), the great Spanish writer, comes back again and again to Velazquez' painting of Christ on the cross. He even published a long poem on "The Christ of Velazquez", of which the beginning verses and those entitled "Death" are here quoted:

" 'Yet a little while, and the world seeth me
no more; but ye see me; because I live
ye shall live also' – Thou didst say; and see,
the eyes of faith grasp thee in the most secret
recesses of the soul and we create,
through art, thy visible form. By the brush
of Don Diego, the great master Velazquez –
his the magic wand. And through it we see
thee in flesh today, thee, the man eternal
that makes of us new men. Thy death is travail.
Thou didst rise to heaven, and thence didst send
the comforter to us, the Holy Spirit,
inspirer of thy faithful flock, that works
in art and brings us our vision of thee.
Incarnate here in this white, silent word
that speaks with lines and with colours, my tragic
people tell their faith. It is the supreme
sacramental drama, for it sets us
high above death and face to face with God."

"Thou art the first born of the dead, thou, ripe
now for death, art fruit of the tree of life,
life that never ends, fruit which we must eat
if we would be free from the second death.
For thou hast made of death, that is the end,
the beginning and the sovereign of life,
white Death wrapped in a cloak of black and riding
on a pale horse; Death, emperor of history,
after he has mown us men down, with conqueror's
avarice stores us away in his granary.
 "The man is the son of God, and is God
of the son of man; thou, Christ, with thy death
hast given the universe human aim
and thou wast the death of Death at the last!"

Miguel de Unamuno

Plate XI
"Crucifixion", painting by Diego Velazquez (1631–32).

23

Plate XI

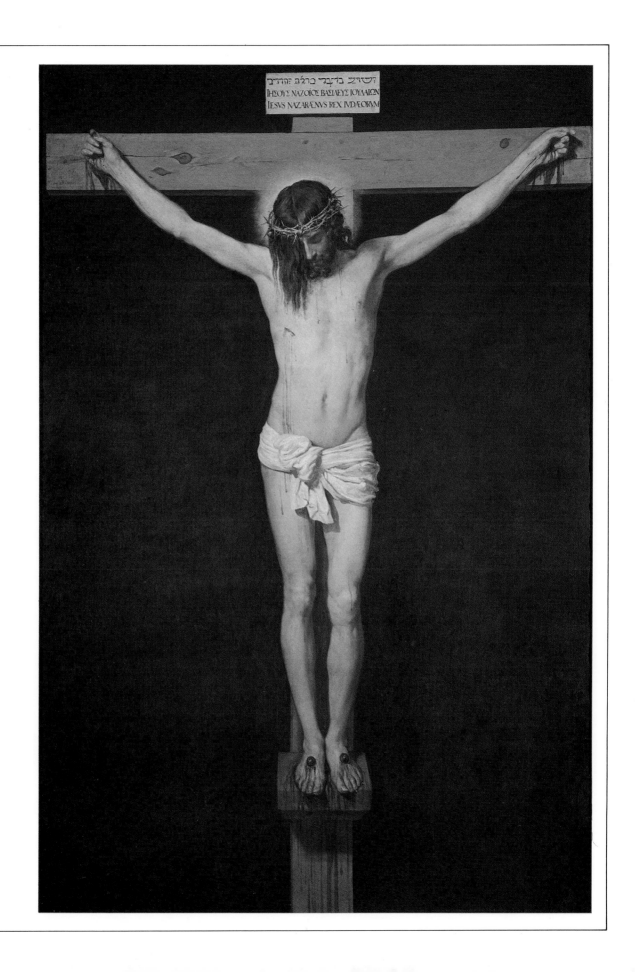

Painted theology of the cross

"One of the criminals who hung there with him taunted him: 'Are not you the Messiah? Save yourself, and us.' But the other rebuked him: 'Have you no fear of God? You are under the same sentence as he. For us it is plain justice; we are paying the price for our misdeeds; but this man has done nothing wrong.' And he said: 'Jesus, remember me when you come to your throne.' He answered: 'I tell you this: today you shall be with me in paradise.'

"By now it was about midday and a darkness fell over the whole land, which lasted until three in the afternoon; the sun's light failed."

Luke 23:39–44

"Luther makes an unambiguous distinction between a theology of glory and the true theology of the cross. The theology of glory, he says, 'prefers works to suffering, glory to the cross, power to weakness, wisdom to foolishness, and in one word evil to good'. But the theology of the cross knows that 'it is not enough for anybody nor does it help him that he recognizes God in his glory and majesty, unless he recognizes him in the abasement and ignominy of the cross' (*Heidelberger Disputation*). In analogy to this we may describe Rembrandt's style as a 'painting of the cross'."

W. A. Visser 't Hooft

Plate XII
"The Three Crosses", 4th version of an etching by Rembrandt (1653).

Plate XII

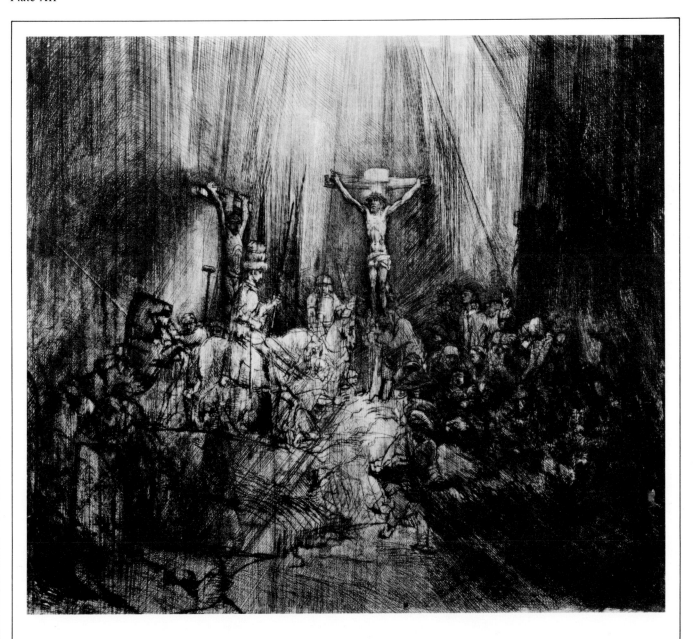

A martyr of God's love

A few years after Gauguin painted his "Crucifixion in Yellow" which shows the ardent piety of Catholic women in Brittany, a young Carmelite nun, Saint Theresa of Lisieux, wrote her "act of consecration", excerpted here:

"I give thanks to you, my God, for all the graces which you have accorded to me, especially that you let me pass through the trial of suffering. With joy will I contemplate you on the last day holding the sceptre of the cross; as you have granted me to participate in this precious cross I hope to resemble you in heaven and to see shine on my glorified body the holy stigmata of your passion . . .

"After the exile on this earth I hope to be in joy with you in the fatherland, but I do not want to gather merits for heaven, I only want to work for your love with the sole aim to please you, to console your sacred heart and to save souls which will love you for ever.

"At the evening of this life I will appear before you with empty hands, for I do not ask you, Lord, to count my works. In your eyes all our righteousness is stained. Therefore I want to put on your own righteousness and receive from your love the eternal gift of yourself. I do not want any other throne and any other crown than you, my beloved! . . .

"In your eyes time is nothing, one day is as a thousand years; you can therefore in one instant prepare me for appearing before you . . .

"In order to live in an act of perfect love, *I commit myself as would a victim of a burnt offering to your merciful love*; I pray: use me up continuously, within my soul let the floods of infinite tenderness overflow which are stored up in you. And so may I become a martyr of your love, O my God!"

Saint Theresa of Lisieux

Plate XIII
"The Yellow Christ", painting by Paul Gaugin (1889).

Plate XIII

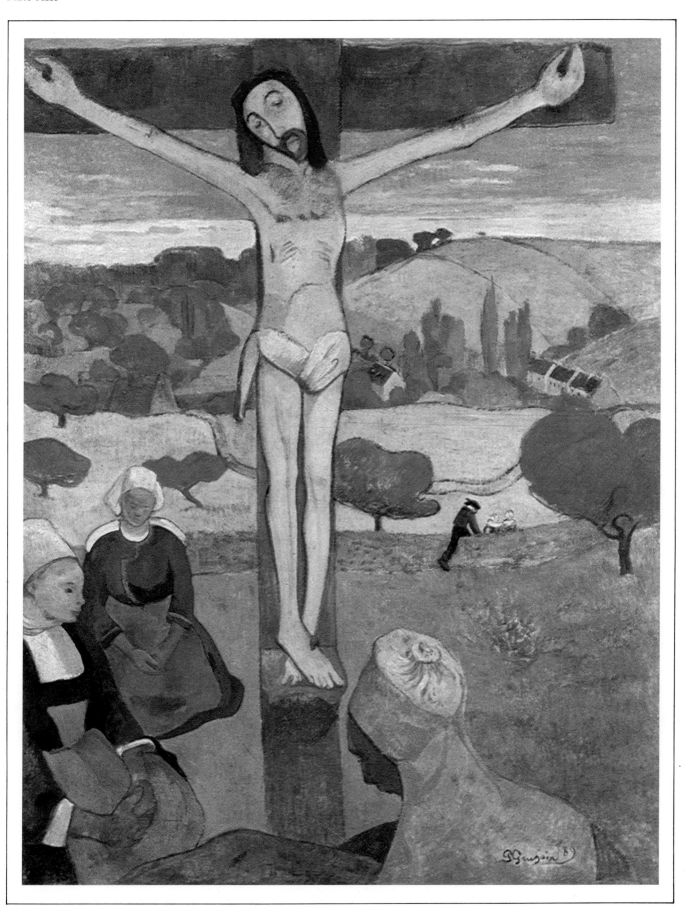

Plate XIII

"Were you there when they crucified my Lord?"

"Suffering often takes the most personally humiliating and opaque character. It incapacitates a man from the very good which was the cause of his greatness in the first place. He can no longer act with that spontaneity and clarity which had so won others. He is now thrown upon the mercy of others, a burden to them; more, he is bewildered and unable to give an account of himself. He cannot explain why or how he suffers; even though once he could reveal, winningly and joyfully, why life took the shape it did, why it was right and fitting that it did so. The scandal of such suffering, suffering that plucks the tongue from the head and the voice from the heart! even to the point that others are scandalized and bewildered. They had concluded over the years that whatever came to pass this man would never cease to be their oracle; the years would only confer on him a clearer, more communicable wisdom. But to be reduced to a deaf mute?

"*Cui bono?* Man does not suffer that a world may be one; he does not suffer, even, that the will of God may be accomplished. He is, in fact, in the deepest suffering, evacuated of all real purpose at all. He is not suffering 'in order that'. His anguish does not allow him to be carried beyond the fact of suffering. And this is true so that the truth of suffering, its value as sign, may shine forth. But only for the few who are ready to read such a sign. Achievements, great moments, visible accomplishments, always have about them so much danger of distraction, egoism, ambiguity. But the sufferer who believes and takes his stand, not precisely on his suffering, nor on the quality of his faith, nor on the 'good' he is doing, nor on the response of his friends, but on Christ alone; which is to say, on the living truth of things – this man, perhaps for the first time, has become a true sign. He is the sign of the cross. There is quite possibly no other in the world today."

Daniel Berrigan

Plate XIV
"Crucifixion No 2", painting by the North American artist
William Congdon (1960).

Plate XIV

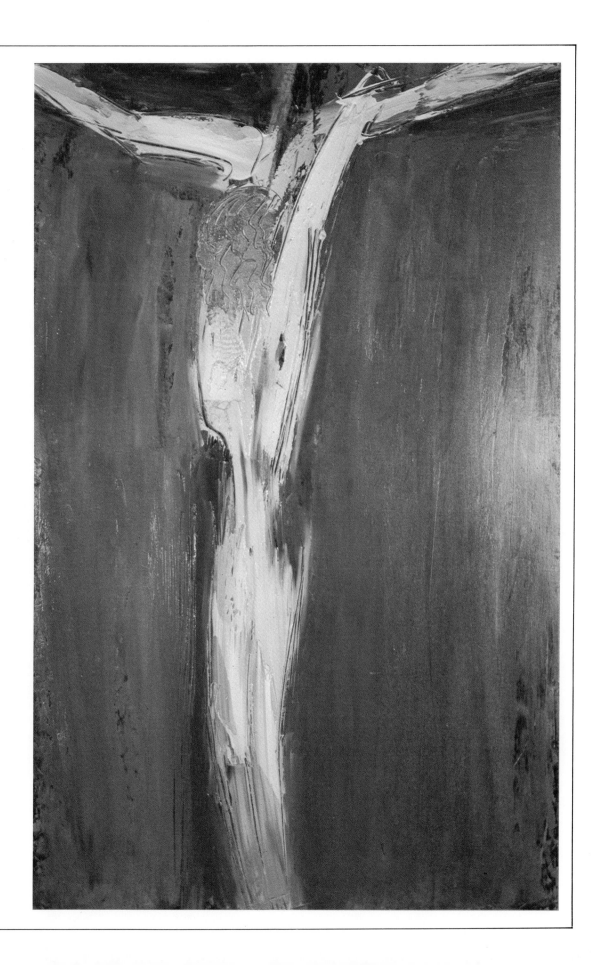

Participation in the suffering of God in the life of the world

"The Christian, unlike the devotees of the redemption myths, has no last line of escape available from earthly tasks and difficulties into the eternal, but, like Christ himself ('My God, why hast thou forsaken me?'), he must drink the earthly cup to the dregs, and only in his doing so is the crucified and risen Lord with him, and he crucified and risen with Christ. This world must not be prematurely written off; in this the Old and New Testaments are at one. Redemption myths arise from human boundary–experiences, but Christ takes hold of a man at the centre of his life." . . .

"God lets himself be pushed out of the world on to the cross. He is weak and powerless in the world, and that is precisely the way, the only way, in which he is with us and helps us." . . .

"To be a Christian does not mean to be religious in a particular way, to make something of oneself (a sinner, a penitent, or a saint) on the basis of some method or other, but to be a man – not a type of man, but the man that Christ creates in us. It is not the religious act that makes the Christian, but participation in the sufferings of God in the secular life."

Christians and Pagans

Men go to God when they are sore bestead,
Pray to him for succour, for his peace, for bread,
For mercy for them sick, sinning, or dead;
All men do so, Christian and unbelieving.

Men go to God when he is sore bestead,
Find him poor and scorned, without shelter or bread,
Whelmed under weight of the wicked, the weak, the
 dead;
Christians stand by God in his hour of grieving.

God goes to every man when sore bestead,
Feeds body and spirit with his bread;
For Christians, pagans alike he hangs dead,
And both alike forgiving.

Dietrich Bonhoeffer

Plate XV
"The Crucified in the Asphalt-Jungle", serigraph by the Swiss artist Paul Le Grand (1973).

Plate XV

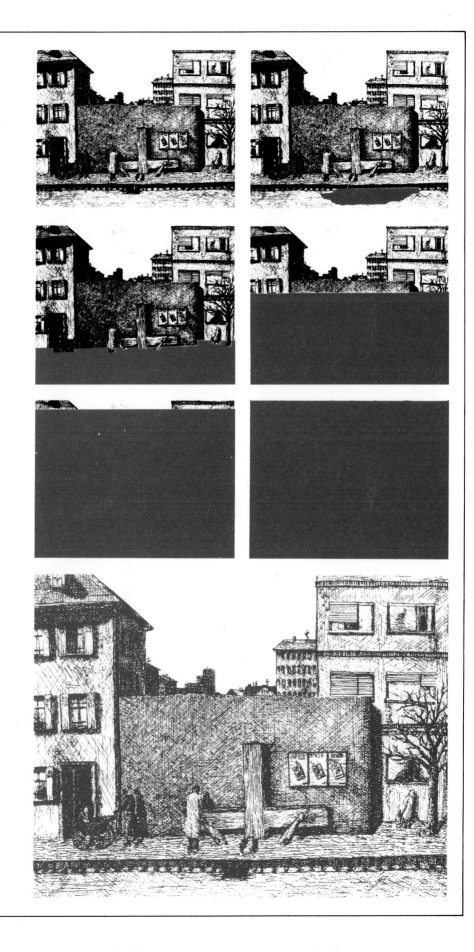

Crusaders' song

Take the good and cast the evil,
Listen, people, to my song,
For 'tis God for whom I'm speaking
To the valiant and the strong.
Take the cross, the cross he died on,
Oh, repay him as ye may:
For by dying he redeemed us,
Can we give him less today?

Counts and princes they may spoil us,
But their spoiling stays at death;
What the treasures of their hoarding
When they give their final breath?
Better far to up and rally
In the good cause I proclaim;
Where at death are earthly honours?
Lost forever, lost in shame.

Cowards! spending time and labour
For your bodies, for a wage;
All shall pass and all shall wither
Soon the youth shall turn to age.
But the guerdons of true virtue
Oh, they live forever more,
Oh, the bitterness of losing
Of their everlasting store!

He to whom the light is given,
He will up for Holy Land
At the day of judgment scathless
When the good from evil stand.
When the world shall mighty tremble
Oh, that soul shall fearless be,
Quailing never such before him
Coming in his majesty!

Help me, God, in this my pleading!
Tardy have we been to free
That thy cross and that thy country
Where the Infidels mock thee.
'Tis our sins that have delayed us
Let us cast them and be free,
Leaving everything behind us,
Finding paradise with thee.

Such an one will all men honour,
If returning God decrees,
Sweet in absence is his country,
Sweeter if once home he sees.
Living still his lovely lady
As he left her hardly won,
Oh, he jousts for her sweet favour
Now his task for God is done.

From Chronicle of
the Dukes of Normandy (1145)

Plate XVI
Crucifix made of maize pasta before a painting with
St Franciscus and St Dominicus above scenes of the hell.
Unknown Mexican artist of the 16th century.

Plate XVI

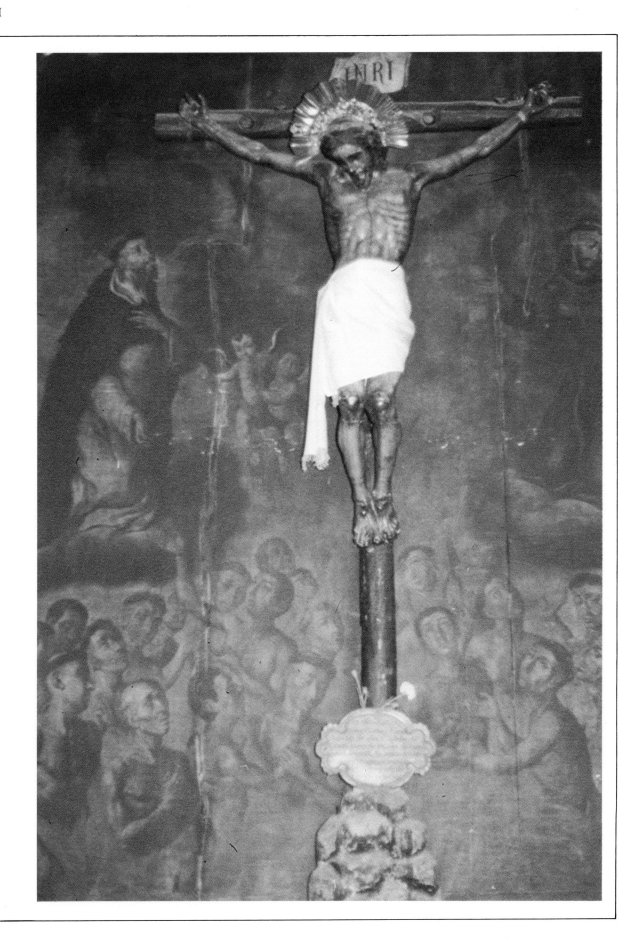

The Spanish Christ

" 'These Christs! – Good God!' he said to me, as we stood before one of the bloodiest of those that are to be found in our cathedrals, 'this thing repels, revolts . . .'

" 'It revolts him who knows nothing of the cult of suffering,' I said . . .

"I confessed to him that I have the soul of my people, and that I like these livid Christs, emaciated, purple, bloody, these Christs that someone has called ferocious . . .

" 'When you see a bull-fight, I continued, you will understand these Christs. The poor bull is also a kind of irrational Christ, a propitiatory victim, whose blood cleanses us from not a few of the sins of barbarism . . .

" 'Do you not remember that terrible paradox of the gospels about having to hate father and mother and wife and children in order to take up the cross, the blood-stained cross, and follow the Redeemer? Hatred of ourselves, when it is unconscious, obscure, purely instinctive, almost animal, engenders egoism; but when it becomes conscious, clear, rational, it is able to engender heroism. And there is a rational hatred, yes, there is.'

"Yes, there is a triumphant, heavenly, glorious Christ, he of the transfiguration, he of the ascension, he who sits at the right hand of the Father; but he is for when we shall have triumphed, for when we shall have been transfigured, for when we shall have ascended. But for here and now, in this bull-ring of the world, in this life which is nothing but tragic bull-fighting, the other Christ, the livid, the purple, the bleeding and exsanguinous."

Miguel de Unamuno

Plate XVII
"Crucifixion", painting by the Mexican artist Gonzalo Ceja (second half 20th century).

Plate XVII

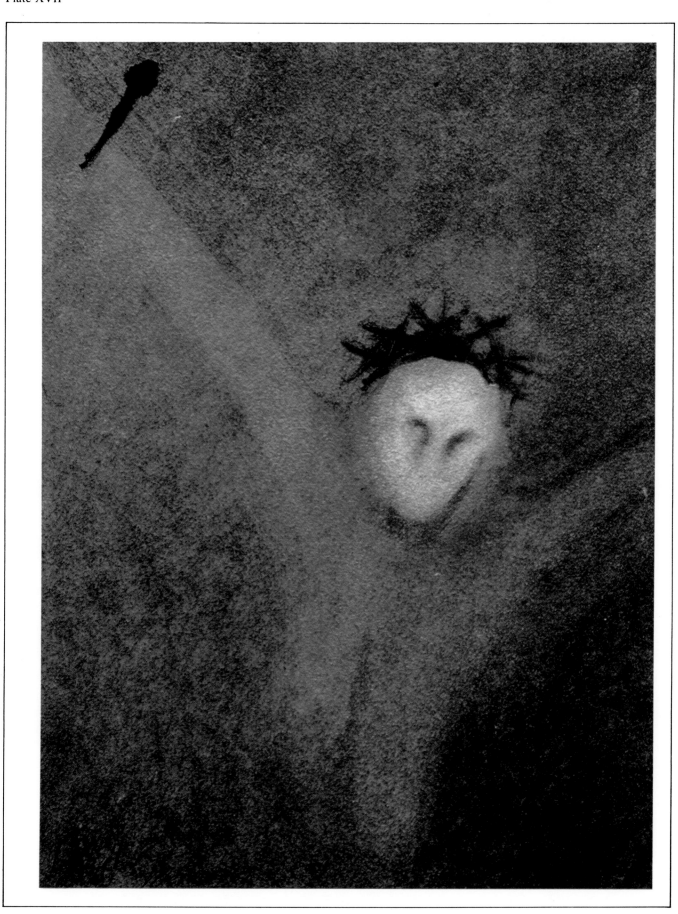

Why have you abandoned me?

My God, my God, why have you abandoned me?
A caricature have I become
and people despise me.
They sneer at me in all the newspapers.

Tanks surround me,
machine guns take aim at me,
barbed wire, loaded with electricity, imprisons me.
Each day I am being called up,
with a number they have branded me
and behind the grate they photographed me.
My bones can be counted like on an X-ray sheet,
Naked they pushed me into the gas chamber
and my clothes and shoes they have shared among
 themselves.
I cry for morphium, but nobody hears me.
I cry in the fetters of the waistcoat,
in the mental hospital I cry the whole night long,
in the ward for uncurable patients,
in the old people's hall for contagiously ill.
In the psychiatric clinic I wrestle perspiring with death.
Even under the oxygen mask I suffocate.
I am in tears at the police station,
in the court of the house of correction,
in the torture chamber,
in the orphanage.
I am contagious with radioactivity
and people avoid me for fear of infection.

But I will tell my brethren about you.
In our meetings I will praise you.
In the midst of large crowds my hymns will be intoned.
The people which still have to be born,
our people,
will rejoice in a great feast.

Ernesto Cardenal

Plate XVIII
Crucifix in wood and clay by the Peruvian artist Edilberto
Merida (second half 20th century).

Plate XVIII

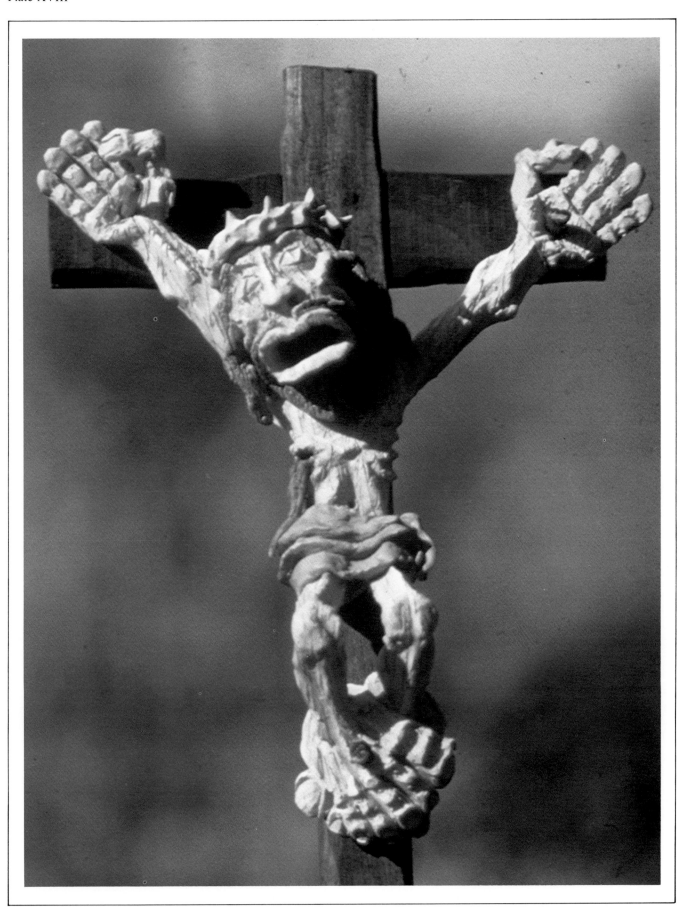

Plate XVIII

He said He was a king

*In Chacabuco, a concentration camp in the desert area
of northern Chile, the following poem was written in
1974 by one of the political prisoners. Some Christian
communities in Chile use it now as a prayer at the
eucharist.*

The armed retinue was mocking
the one crowned with thorns,
they took off his rags
and beat his head with a cane.
Offensive mouths spat on the man
with the long hair, rebel eyes and unkempt beard.

So, mocked by the soldiers
and with a mistreated body,
a bloodied man was dying
before the eyes of the high priests –
supreme hypocrisy, supreme meanness and greed.

Today I remember you, a freedom-loving Christ,
vagabond in time, dubious in space.
Were you Spartacus' brother,
contemporary of the slave or comrade worker?

What matters the chain, the fiefdom, the wage;
to be Nazarene or Chacabuco inmate
if you are on earth, brother Christ.
Son, with dirty face and calloused hands,
flesh and blood of the people, lord of history
at home with the plane and the hammer,
a distinguished carpenter;
or with the shovel, pick and pointed stick,
a noble road builder . . .

Eternal resident of the poor and barren hovel
with roof of tin or stars, floor of sand or dirt,
modest or captive walls.
You do not dwell in the oppressive mansion,
the cave of thieves or the palace of Caesar.

The ingenuously pious faithful swear they will find
you in the fixed and shallow rite,
in the golden chalice and the simplistic devotion
of those who cry 'Lord, Lord'
but who, after going through the motions, do nothing.

In preference to these I choose the good samaritan
who does not preach about heaven
but seeks paradise on earth,
not an eternal calvary – a hell of illiterate poor.

Yes, I prefer the witness
of the one who walks, suffers and loves,
of one who sings, weeps and loves,
of one who struggles, dies and loves.

(continued overleaf)

Plate XIX
"The Power of the Powerless", drawing by the Mexican
artist Rolando Zapata (1976).

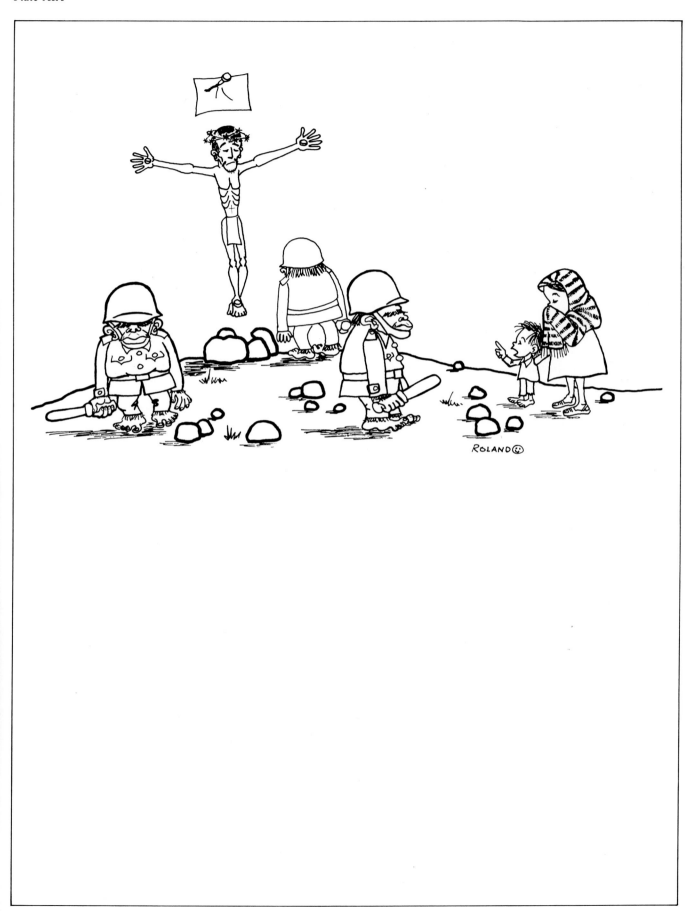

Plate XIX

I understand you, Christ,
because I know betrayal and the spear,
because, like you, I say
I am king and claim my crown.

I ask to be monarch of my own destiny
and father of all children,
I desire emancipation for myself and brothers.

I demand a sceptre for a poor and earthly kingdom,
but dignified and free,
built by the brotherhood of creative hands
in a community of equality and historic prophecy.

That sceptre is mine and I claim it today,
because what I stand for is greater
than the cross I carry,
because my cheeks are tired of the Pharisee's blows
and my arm is asking for the whip.

And when the whir of my whip is silent
and the temple empty of merchants,
then the thorns, the hate and the vinegar,
the scoffing and weeping will be changed into
a welcome to the repentant centurion,
into kindness, poetry, and work,
because the man brought back to life
is always incarnating himself in his children . . .
and Christian hope has the face of a child.

Poem by a political prisoner in
a Chilean concentration camp

Plate XX
"The Tortured Christ", sculpture by the Brazilian artist
Guido Rocha (1975).

Plate XX

The Bread of heaven

Before eucharist, while the choir sing the hymn "Holy, Holy, Holy", the assistant clergy kneel and the fans are shaken, while the priest extends his arms and silently recites the following prayer:

"Holy, Holy, Holy. Truly you are the most holy. Who is there who can describe the gift that flows down upon us unceasingly? Because you protected and comforted our ancestors in many ways by prophecies, by the law, the priesthood and the sacrifice of the oxen, which was a foreshadow of that which was to come. And when finally he did come, you destroyed our sins and gave us your only son, the debtor and the debt, the sacrifice and the anointed, the lamb and the bread of heaven, the priest and the victim, because it is he who gives and he who is always inexhaustibly given to us. Truly he was man by a union without fusion and was born of the mother of God, the virgin Mary, and in everything except sin lived as man. He was the saviour of the world and the cause of our salvation."

Before the closing blessing the priest says:

"O Christ our God, keep your servants under the shadow of your holy and most honoured cross; deliver us from both visible and invisible enemies, and grant that we may thank and praise you, together with the Father and Holy Spirit, now and forevermore, worlds unceasing."

Armenian Orthodox Liturgy

Plate XXI
Armenian *khatchkar* at Haghbat, Armenia (1272).

Plate XXI

Contemporaries of that memorable day

According to the Koran it was not Jesus who was crucified. Surah iv.156 reads: "They [i.e. the Jews] say: We killed the Messiah, 'Isā [Quranic name for Jesus], son of Mary, the apostle of God. But they did not kill him, nor did they crucify him. It seemed so to them. Those who had altercations on this matter are dubious about it, and in fact in the absence of sound knowledge are following conjectures. The sure fact is they did not kill him. On the contrary, God raised him to himself, God the strong and the wise." While still holding to this belief many Muslims have deeply meditated on Jesus' suffering and readiness to die. The following is the beginning of a philosophical novel about Golgotha by M. Kamel Hussein, a modern Egyptian Muslim thinker.

"The day was a Friday. But it was quite unlike any other day. It was a day when men went very grievously astray, so far astray in fact that they involved themselves in the utmost iniquity. Evil overwhelmed them and they were blind to the truth, though it was as clear as the morning sky. Yet for all that they were people of religion and character and the most careful of men about following the right." . . . "Their Roman overlords, too, were masters of law and order, yet these proved their undoing." . . .

"On that day the Jewish people conspired together to require from the Romans the crucifixion of Christ, so that they might destroy his message. Yet what was the mission of Christ save to have men be governed by their conscience in all they did and thought? When they resolved to crucify him it was a decision to crucify the human conscience and extinguish its light." . . .

"On that day men willed to murder their conscience and that decision constitutes the supreme tragedy of humanity. That day's deeds are a revelation of all that drives men into sin. No evil has ever happened which does not originate in this will of men to slay their conscience and extinguish its light, while they take their guidance from elsewhere. There is no evil afflicting humanity which does not derive from this besetting desire to ignore the dictates of conscience. The events of that day do not simply belong to the annals of the early centuries. They are disasters renewed daily in the life of every individual. Men to the end of time will be contemporaries of that memorable day."

M. Kamel Hussein

Plate XXII
"Descent from the Cross", painting by an unknown North Indian Muslim artist of the 16th–17th centuries.

Plate XXII

Cast down, but not destroyed

"O Lord, we pray thee that thy church, in the midst of tribulations and temptations, may remain steadfast and faithful to thy mission.

"May thy followers, in the midst of unpopularity and persecution, be not ashamed of acknowledging thy lordship, nor of witnessing to thy gospel of salvation. O God, give them courage, hope, and strength, that they may be able to stand the severe tests and overcome the temptations. May they be conscious of the fact that Christ is far above all principality and power and might and dominion and every name that is named, not only in this world, but also in that which is to come.

"We pray that through all trials, thy servants may come out like the apostle Paul: troubled, but not distressed; perplexed, but not in despair; persecuted, but not forsaken; cast down, but not destroyed.

"Help them and strengthen them, O Lord. We pray in the name of Jesus Christ, our Lord and Saviour."

S. C. Leung

Plate XXIII
"Calvary", painting by Wang Su-Ta (first half 20th century).

Plate XXIII

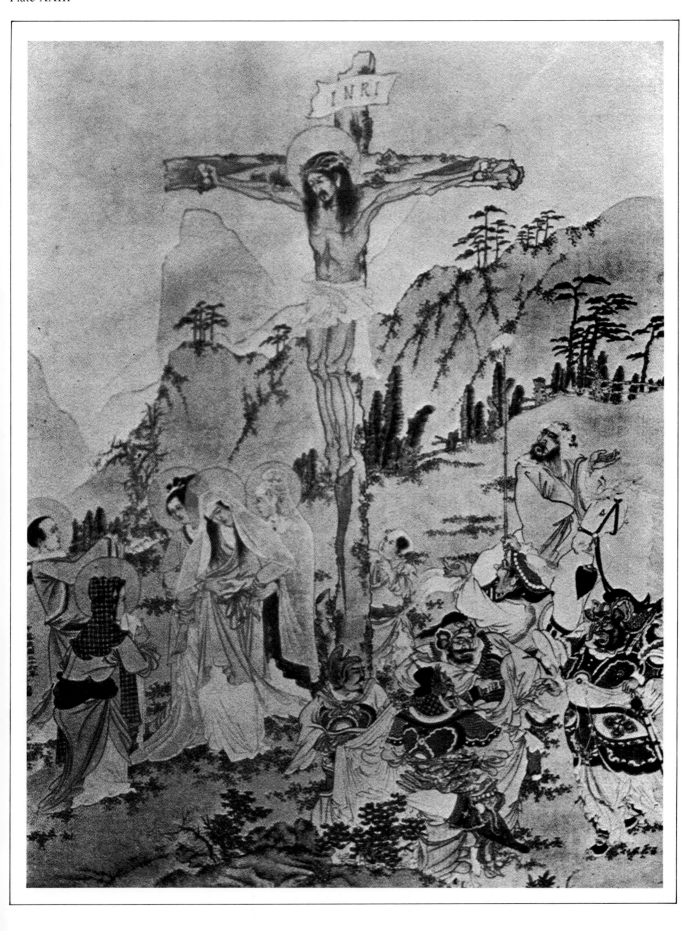

Vision of the Risen Lord

"The cross has meant despair and disillusionment, not only to Jesus' disciples who had thought in terms of earthly power, but even to those who have shared in some measure his vision of the kingdom. If that is the end of it all, they ask, why waste life? Jesus was either a stranger, they say, in a strange world created by a strange god, or one who was good but lacking the power to make his goodness effective.

"It is the resurrection of Jesus that brings us assurance. It was the risen Lord who inspired his wavering disciples with courage and confidence. They woke up, after the sleep of uncertainty and the spell of despair, to see the living Christ in their midst, to the assurance of the ultimate victory of the cross.

"Almighty Father, remove our despair and renew our faith. Grant us a vision of your son, victorious over suffering and death, so that we too may be filled with his faith in the infinite power of self-emptying love. Grant that we too may share your cross and inherit your kingdom."

M. M. Thomas

Plate XXIV
Crucifixion batik by Bagong Kussudiardja, Yogyakarta, Indonesia (second half 20th century).

Plate XXIV

The pistol and the cross

In April 1972 the South Korean poet Kim Chi Ha published a long poem called "The Six Bullet Pistol Worship", which is here summarized. It is full of Korean symbolism and allusions to the present Korean political situation. The magazine in which the poem appeared was immediately seized and the poet imprisoned. The powerful had become fearful of the truth and power of the powerless, and Kim Chi Ha still pays the price for his testimony to the crucified Lord with the loss of his freedom.

A mighty king was celebrating the victory over his enemies, when a terrible illness overtook him. Only the eating of the liver of 3,000 living persons can heal him. All communists having already been killed, the king gathers the most vigorous Christians of his country, trying to persuade them to give him their livers. Persuasion does not work and he threatens the assembled crowd with his six-bullet pistol. Yet the Christians begin to laugh when they see the king's confidence in the power of his pistol. Finally the angry pistol-worshipper discovers behind the Christians a small crucifix. He exclaims: "Now I understand. I wondered on what you in fact put your confidence. I see now that your power comes from that small man on the cross. But look, I will destroy him with my six-bullet pistol."

The king shoots at the crucifix and immediately blood begins to flow from the cross. It is like a fountain whose stream nobody can stop. The frightened king calls on his army, his tanks and fighter planes, yet nothing can reverse the stream of blood.

The poem ends with an apocalyptic vision where finally the king and his whole reign are destroyed in the chaos created by his pistol.

Kim Chi Ha

Plate XXV
"Reconciliation", metal sculpture by Keiji Kosaka, Japan (second half 20th century).

Plate XXV

Lifted up to God's glory

"This Son of Man must be lifted up as the serpent was lifted up by Moses in the wilderness, so that everyone who has faith in him may in him possess eternal life. God loved the world so much that he gave his only Son, that everyone who has faith in him may not die but have eternal life. It was not to judge the world that God sent his Son into the world, but that through him the world might be saved."

"Jesus said to them: 'When you have lifted up the Son of Man you will know that I am what I am. I do nothing on my own authority, but in all that I say, I have been taught by my Father. He who sent me is present with me, and has not left me alone; for I always do what is acceptable to him.' As he said this, many put their faith in him."

"I have spoken thus to you, so that my joy may be in you, and your joy complete. This is my commandment: love one another, as I have loved you. There is no greater love than this, that a man should lay down his life for his friends. You are my friends, if you do what I command you. I call you servants no longer; a servant does not know what his master is about. I have called you friends, because I have disclosed to you everything that I heard from my Father. You did not choose me: I chose you. I appointed you to go on and bear fruit, fruit that shall last; so that the Father may give you all that you ask in my name. This is my commandment to you: love one another."

"Father, the hour has come. Glorify thy Son, that the Son may glorify thee. For thou hast made him sovereign over all mankind, to give eternal life to all whom thou hast given him. This is eternal life: to know thee who alone art truly God, and Jesus Christ whom thou hast sent. I have glorified thee on earth by completing the work which thou gavest me to do; and now, Father, glorify me in thy own presence with the glory which I had with thee before the world began."

John 3:14–17; 8:28–30; 15:11–17; 17: 1–5

Plate XXVI
Painted crucifixion relief by a Christian mystic *guru* (second half 20th century).

Plate XXVI

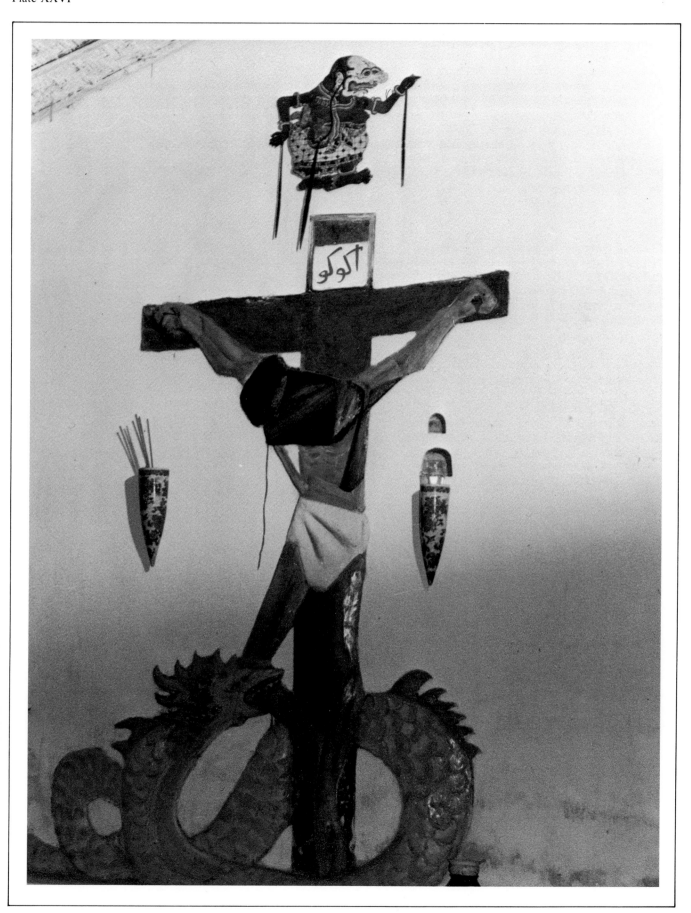

Plate XXVI

He stretched out his hands

Priest (during preparation of the eucharist):
"O God and our Lord, who stretched out your holy hands on the cross, lay your holy hands upon this paten which is full of goodness and on which food of a thousand years is prepared by those who love your holy name.

"Now also, O Lord and our God, bless and consecrate and purify this paten, which is ablaze with heavenly fire to offer your holy body on this holy altar in this holy, apostolic church, for to you with the good, heavenly Father and the Holy Spirit, the life-giver, belongs all glory now and evermore, worlds unceasing. Amen."

Priest (during the eucharist):
"He stretched out his hands during the passion, suffering to save those that trusted in him; he was delivered to the passion that he might destroy death, sever the bonds of Satan, destroy hell, lead out the saints, and announce his glorious resurrection."

People (after the eucharist):
"May God bless us, his servants. May we receive remission of our sins through the reception of the body and blood of Christ, our Lord. May the Holy Spirit enable us to conquer all the influence of the devil. We all look for the blessing from your merciful hands, and may we be united in our performance of charitable works.

"May God be blessed in giving us his precious body and blood and may we find life through the power of the cross of Christ.

"To you, O God, we give thanks for all the graces we have received through the Holy Spirit."

Ethiopian Orthodox Liturgy

Plate XXVII
Painted illustration of crucifixion in St Arsima Manuscript, Ethiopia (14th–15th centuries).

Plate XXVII

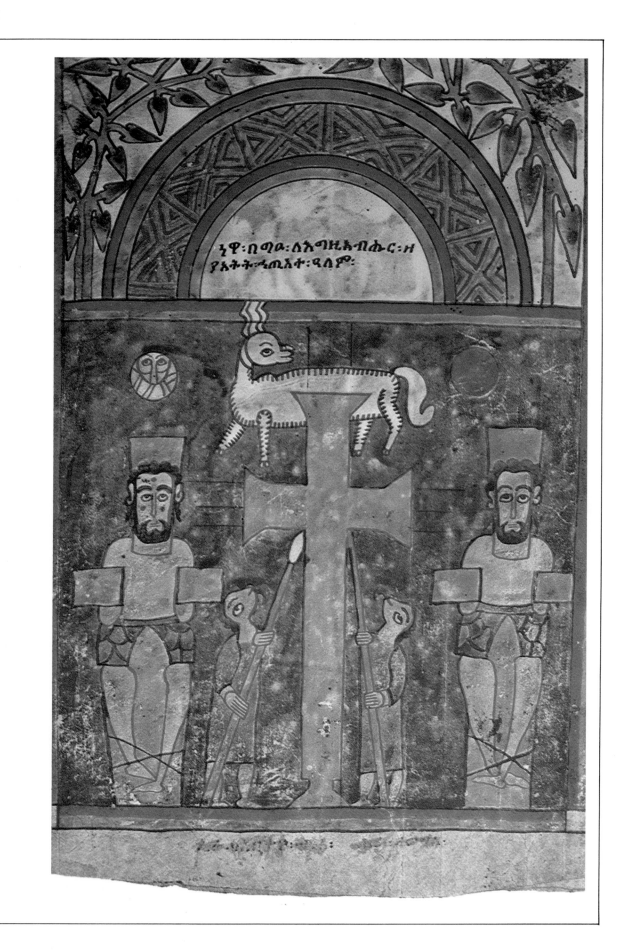

The redeemer's tree

"The cross is the most universal symbol of Christianity. But often we forget that the symbol of our salvation was originally a tree growing somewhere, probably among many other trees. Those who cut it down had not the slightest idea that it would one day become the most universal symbol of millions upon millions of Christians. They thought nothing about the fact that on that tree God would be crucified in order to reconcile the world to himself; that on that tree redemption was to flow from God to mankind in a once-and-for-all act of self-sacrifice." . . .

"This is the tree which causes discomfort to the world, which has turned the world upside-down. It is the tree which the world cannot erase, cannot get rid of, and cannot forget.

"The tree of the cross has built bridges across rivers and valleys; it has brought people of different backgrounds together; it has torn down barriers and pierced through walls of separation; it has crossed oceans and travelled afar to tell people the good news which it heard one Friday morning two thousand years ago. Indeed this tree has been persecuted, whacked with axes, shot at with bullets, hanged, beaten, given to wild beasts, torn to pieces, chopped up, ostracized, burned, laughed at, condemned, and made to suffer many other things. This tree bears upon itself thousands of scars and wounds. Yet in spite of them all, it has continued to heal the sick, to bring hope to the desperate, to comfort the oppressed, to guide the lost, to feed the hungry, to shelter the poor, to inspire the anxious, to illumine the intellectual, to challenge the fearless, to save the condemned and to meet the needs of every generation and every human situation. What a tree!"

John Mbiti

Plate XXVIII
Crucifix, wood sculpture by an unknown East African artist (second half 20th century).

Plate XXVIII

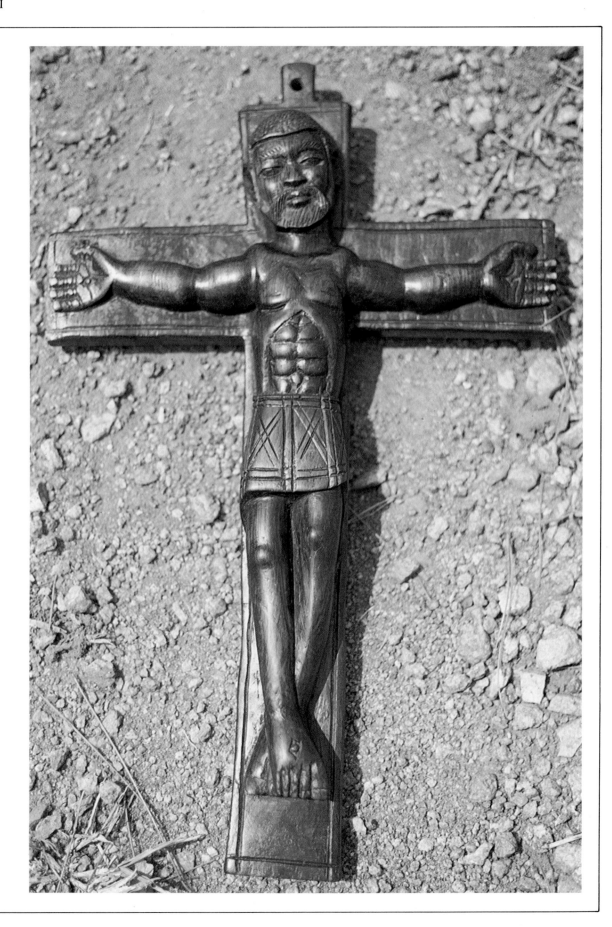

Plate XXVIII

He came down to earth to shed his blood

Our Jesus is Saviour, Lord and friend;
he searched all our life from end to end.
And he came down to earth to shed his blood on
 Calvary,
all to give life to men.

The city rejoices, the children sing:
"A day of joy: behold our King!"
Sing alleluia, for Christ the Lord is risen,
all to give life to men.

The table is set in an upper room;
the bread and the wine foretell his doom.
And he came down to earth to shed his blood on
 Calvary,
all to give life to men.

In form of a servant he washes their feet,
and says "Thus humbly each other greet".
And he came down to earth to shed his blood on
 Calvary,
all to give life to men.

They all go with him to Gethsemane,
but in Pilate's courts there is none but he.
And he came down to earth to shed his blood on
 Calvary,
all to give life to men.

"Not guilty," says Pilate, and washes his hands,
"Away with him now!" the crowd demands.
And he came down to earth to shed his blood on
 Calvary,
all to give life to men.

Before evening falls, it all is done;
the tomb receives our Holy One.
And he came down to earth to shed his blood on
 Calvary,
all to give life to men.

Where are the disciples? Where now are his friends?
The Lord is dead: and here all hope ends
. . . (silent pause)

Two nights and a day, and the news is abroad:
not end but beginning! alive is the Lord!
Sing alleluia, for Christ the Lord is risen,
all to give life to men.
Sing alleluia, for Christ the Lord is risen,
all to give life to men.

So praise we God's love for what Jesus has done.
Now death is defeated, and victory won.
Sing alleluia, for Christ the Lord is risen,
all to give life to men.

Abel Nkuinji

Plate XXIX
Crucifixion scenes from a Via Crucis, wood relief by a
Nigerian artist (second half 20th century).

Plate XXIX

The mediator of the new covenant

"Now Christ has come, high priest of good things already in being. The tent of his priesthood is a greater and more perfect one, not made by men's hands, that is, not belonging to this created world; the blood of his sacrifice is his own blood, not the blood of goats and calves; and thus he has entered the sanctuary once and for all and secured an eternal deliverance. For if the blood of goats and bulls and the sprinkled ashes of a heifer have power to hallow those who have been defiled and restore their external purity, how much greater is the power of the blood of Christ; he offered himself without blemish to God, a spiritual and eternal sacrifice; and his blood will cleanse our conscience from the deadness of our former ways and fit us for the service of the living God. And therefore he is the mediator of a new covenant."

"He has appeared once and for all at the climax of history to abolish sin by the sacrifice of himself. And as it is the lot of men to die once, and after death comes judgment, so Christ was offered once to bear the burden of men's sins, and will appear a second time, sin done away, to bring salvation to those who are watching for him."

Hebrews 9:11–15, 26–28

Plate XXX
"Golgotha", painting by Gebre Kristos Desta, Ethiopia (1963).

Plate XXX

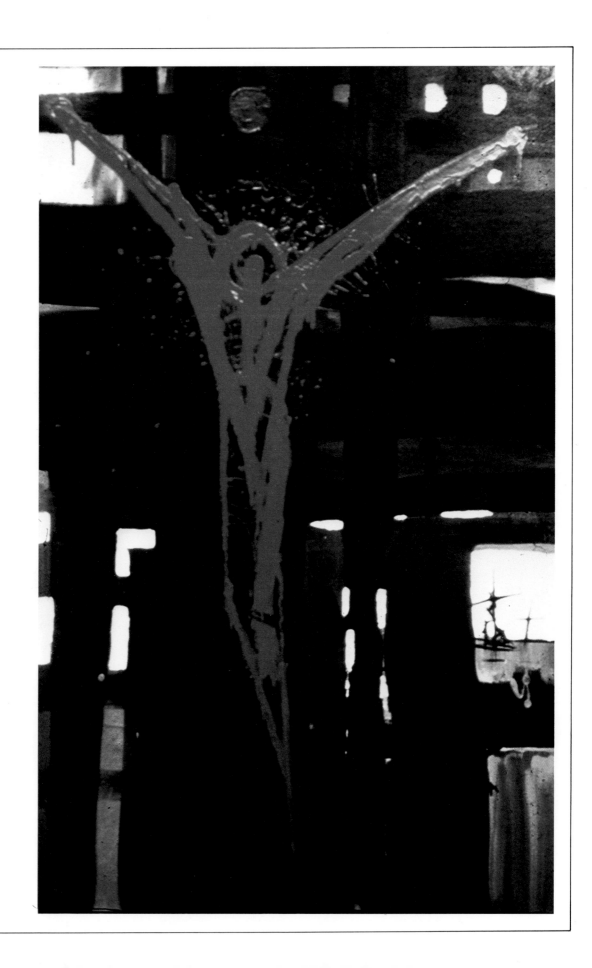

The Christ in majesty

"The Christ in majesty which stands above the altar recapitulates the offering of the whole world and humanity in the sacrifice of the cross. At the foot of Christ crucified stand the martyrs of Uganda; they are the image of all those people in Africa who have united the sacrifice of their lives to that of Christ crucified. The cross rises against a cosmic background of cruciform patterns (the four points of the compass), of sun and moon motifs (circles and crescents), and of triangular and diamond shapes, symbols of fertility and life. The whole is in the three fundamental colours: red the colour of life, black the colour of suffering, white the colour of death. Thus Africa, mankind, the whole cosmos, are evoked and comprised in the vast gesture of Christ on the cross: 'Father, into thy hands I commend my breath of life.' But the splendour and majesty of this cross sings the paschal triumph of the resurrection: 'I am the resurrection and the life; he who believes in me, though he die, yet shall he live, and whoever lives and believes in me shall never die.'"

Engelbert Mveng

Plate XXXI
Crucifixion fresco on the apse of the Chapel Libermann College in Douala, Cameroun, by the Cameroun artist Engelbert Mveng (second half 20th century).

Plate XXXI

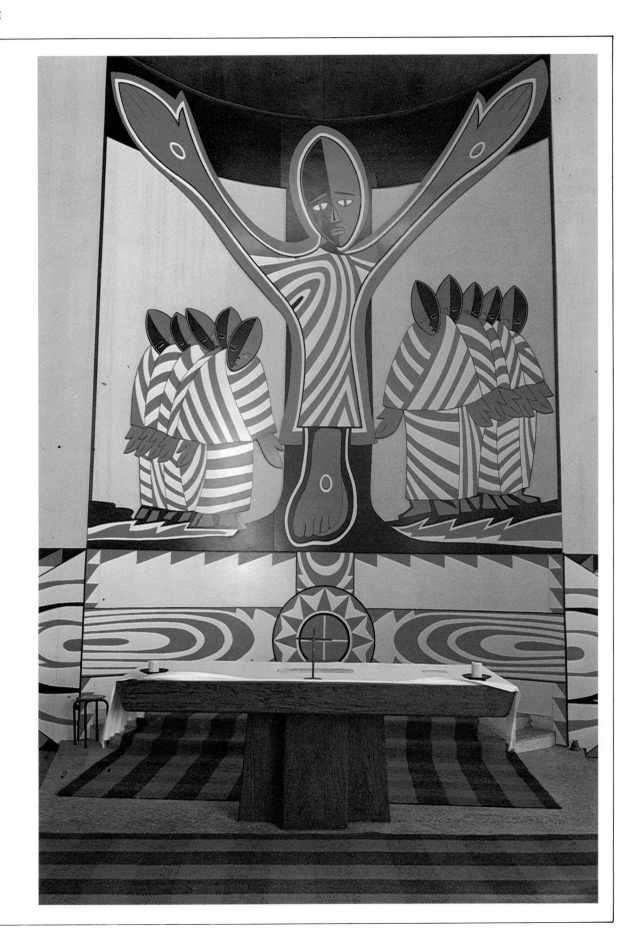

The cross as cost of fellowship

"Fellowship is not cheap. I have learned this as one who comes from a people who experienced slavery, and who have known political and economic oppression. The cost of fellowship is the cross. It is only as the cross becomes a central part of our life that we will really draw closer together in unity and witness. And that cross means the denial, the giving up of much that we consider precious but is not really central to our faith in Christ, our crucified and risen Lord. As St Paul put it so well in his letter to the Philippians, we must give up all things in order that we might know Christ in the power of his resurrection and in the fellowship of his sufferings. We can bear together the sufferings of our particularities as we live by this power of Christ's resurrection, that 'standing up' relationship in which we can look at each other eye-to-eye and mouth-to-mouth, and face the world with the love and yet with the judgment of God. But the cross means the scandal of particularity of the incarnate Lord who lived, died, and was raised, in a particular time and place. Particularity means each place, each situation, each man, each woman. That is why we are at present engaged in the Programme to Combat Racism, in the issues of international affairs, in development, in urban industrial mission, in inter-church aid, etc. – and, in fact, the very things which so many of us say are tending to divide us and to divert us from the centralities. But the centralities find expression precisely in this incarnate engagement with the world. That is why I find that to speak of vertical and horizontal, to speak of transcendent and immanent, as separate entities is a denial of the gospel of the incarnate, crucified and risen Lord. That is where I stand, and I stand with you in the knowledge that we will not only stay together, grow together, go forward and act together, as we have said in successive meetings, but also suffer together under the sign of the cross and in the power of the risen Lord."

Philip Potter

Plate XXXII
"Crucifix", wood sculpture by Samuel Wanjau, Kenya (1977).

Plate XXXII

Crucified with Christ

"Have you forgotten that when we were baptized into union with Christ Jesus we were baptized into his death? By baptism we were buried with him, and lay dead, in order that, as Christ was raised from the dead in the splendour of the Father, so also we might set our feet upon the new path of life.

"For if we have become incorporate with him in a death like his, we shall also be one with him in a resurrection like his. We know that the man we once were has been crucified with Christ, for the destruction of the sinful self, so that we may no longer be the slaves of sin, since a dead man is no longer answerable for his sin. But if we thus died with Christ, we believe that we shall also come to life with him. We know that Christ, once raised from the dead, is never to die again: he is no longer under the dominion of death. For in dying as he died, he died to sin, once for all, and in living as he lives, he lives to God. In the same way you must regard yourselves as dead to sin and alive to God, in union with Christ Jesus."

Romans 6:3–11

Plate XXXIII
Ancient Christian baptistery from 5th or 6th century at Jalyssos, near the monastery Philerimos on the island of Rhodes.

Plate XXXIII

Part Two

Across frontiers of centuries and cultures

"Everything transitory is only a simile. What we see is but a suggestion, a possibility, a makeshift. True reality lies invisible underneath." . . . "Art does not reproduce the visible, but makes visible."

Paul Klee

"He had no beauty, no majesty to draw our eyes,
no grace to make us delight in him;
his form, disfigured, lost all the likeness of a man,
his beauty changed beyond human semblance.
He was despised, he shrank from the sight of men,
tormented and humbled by suffering;
we despised him, we held him of no account,
a thing from which men turn away their eyes."

Isaiah 53:2–3

"So the Word became flesh; he came to dwell among
 us,
and we saw his glory, such glory as befits the
Father's only Son, full of grace and truth."

John 1:14

The symbol and the reality

Originally the cross had nothing to do with the death of Jesus. It appears in many cultures and has many meanings. Sometimes it points to the sun which was worshipped as a divinity. Sometimes it is a symbol of totality, pointing to all parts of the cosmos. Other cross marks have still other meanings.

Among the Jews at the time of Jesus the cross was known as the *tau*, the last letter of the Hebrew alphabet which formerly was written as a standing or an oblique cross with corresponding letters in the Greek and Latin alphabet. This *tau* had a special significance. It functioned as a symbol of belonging to God, as a sign of penitence and protection. The prophet Ezekiel saw it as such in his vision of the coming judgment on Jerusalem (Ezekiel 9:3–6).

This probably was also the way in which Jesus and the Jewish Christians first understood the cross: as a seal and symbol of belonging and protection. "Anyone who wishes to be a follower of mine must leave self behind; he must take up his cross, and come with me" (Mark 8:34). Those who follow Jesus, be they children, women or men, must bear the *tau* on their foreheads. They no longer belong to themselves. They are Christ's, stand under his protection and thus receive a new identity. Later, in baptism, the cross sign was in fact made upon those who joined the company of Christ.

This, however, was not the only way in which the early church and the evangelist Mark understood the saying of Jesus. For them the cross had become inseparably linked with the person of their Lord and the way in which he died and rose again. Therefore they did not consider it accidental that the first letter in the title of Christ was the Greek letter *chi* which was written as an oblique or upright cross. From the first century onwards, the cross mark indeed became a secret sign of recognition among Christians. Wherever they saw the shape of a cross, whether in combinations of letters or in everyday objects, for instance the anchor, Christians discerned a hidden pointer to their Lord and a confession of their faith. The most striking example of this is the way in which Coptic Christians in Egypt saw the *ankh* sign (†), the ancient pharaonic hieroglyph for "life", as pointing to Christ.

"On the cross God has stretched out his hands to embrace all the ends of the oikoumene (the whole inhabited world). Therefore this mountain of Golgotha is the cardinal point of the cosmos." So spoke Cyril, bishop of Jerusalem, in the fourth century when he addressed a group of baptismal candidates who gathered at Golgotha. In the same century Gregory of Nyssa taught in his catechism how the figure of the cross shows us God's presence in the whole cosmos and how God therefore precedes all human thought.

When the early Christians began to identify the cross mark with the person of Christ they also thought of what happened on that Friday noon just outside Jerusalem. But they did not separate the event of Golgotha from the subsequent resurrection of their Lord. For them the cross was never the sign of a sad memory, but always a reminder of the presence of their crucified and risen Lord. What Jews and Jewish Christians understood essentially as a symbol of belonging and protection has for gentile Christians and the ancient church become a symbol of victory and triumph. From the fourth century onwards, therefore, the cross is often adorned with precious stones. On the so-called "passion sarcophagi" this jewelled and adorned cross becomes central, not as a memory of Christ's sufferings and passion but as the confession of Christ's victory. Thus the central portion of the most famous passion sarcophagus (c. A.D. 340) does not recall the hours of agony but the hour of triumph when the soldiers sleep before the already empty tomb. The cross is shown as the throne. The crown of thorns has become the crown of laurels which the imperial eagle brings down from heaven. It is indeed as Venantius Fortunatus, the Christian poet of the sixth century, sang: "God reigns from the tree."

The most powerful expression of this early Christian understanding of the cross can be seen in the large apsis mosaic in the Basilica Sant'Apollinare de Classe near Ravenna (*Plate I*). Here the victory of the cross initiates the transfiguration of the cosmos. In this sixth century mosaic the cross is interpreted as the symbol of transfiguration. Fortunatus' hymns of the cross were written in the same century and they interpret the mood of the anonymous artists of Ravenna when they created this masterpiece of early Christian art.

In the Basilica Sant'Apollinare the richly adorned cross has been lifted up into a heavenly world to become the centre of the new heaven and the new earth. Perhaps for the first time in western Christian art, the face of Jesus appears at the place where the two arms of the cross meet. Jesus is not yet shown as the one hanging on the cross. Nevertheless, his human face reminds onlookers that the cross became a symbol of victory and transfiguration only because of what happened in Palestine on a Friday noon of the year A.D. 30.

At first sight the reality of crucifixion totally contradicts the cross as a symbol of triumph and transfiguration. It was so horrible that the highly educated Roman orator Cicero said in his defence of senator C. Rabirius: "Should death be threatening, then we want to die in freedom. The executioner, the covering of the head and the mere mention of the word 'cross' must all be banned not only from the body and life of Roman citizens, but also from their thoughts, eyes and ears."

The reality of crucifixion was indeed abhorrent, yet in the Palestine of Jesus' time such executions were no uncommon sight. The Jewish historian Flavius Josephus describes what happened in A.D. 70 when the Roman general Titus besieged the city of Jerusalem. Every day Jews were caught trying to get food outside the walls of Jerusalem: "When caught . . . they were scourged and subjected to torture of every description, before being killed, and then crucified opposite the walls. Titus indeed commiserated with their fate, five hundred or sometimes more being captured daily . . . His main reason for not stopping the crucifixions was the hope that the spectacle might perhaps induce the Jews to surrender, for fear that continued resistance would involve them in a similar fate. The soldiers, out of rage and hatred, amused themselves by nailing their prisoners in different postures; and so great was their number, that space could not be found for the crosses nor crosses for the bodies."

The reality of crucifixion became even more heart-rending in 1968 when, for the first time in history, the earthly remains were found of a man who had been crucified in ancient times. A stone chest in one of the tombs of a large cemetery near Jerusalem contained his bones. The cemetery dates from around the first century, and the name on the coffin reads "Jehohanan ben Hagqol".

Jehohanan was a contemporary of Jesus. Archaeologists and medical doctors were able to deduce several details of his life and death. He probably belonged to a wealthy family. His asymmetric skull indicates that even in his mother's womb some traumatic experience must have endangered his life. At the moment of crucifixion he was a healthy young man in his late twenties. His feet had been pressed against the pole of the cross by a small board. The nail fixing it apparently got caught in a knot of the wooden pole, so the executioners cut off his feet when they took down the body. This is why the large nail piercing his ankle bones was buried with the body. From the angles of the bone fractures it was possible to determine Jehohanan's position on the cross. Both wrists were fixed with nails on the cross beam. The victim was "sitting" on a wood block, so that his agony would be prolonged and he would die only after struggling for many hours against slow suffocation. By skull measurements doctors could even reconstruct Jehohanan's facial expression. Across many centuries a man now looks at us from their drawings of his execution, one of those thousands of Jews who lost their lives because of their zeal for the God of Israel. We are brought face to face with the hard reality of crucifixion.

Why is it that the crucifixion of Jesus has been remembered so long and become a focal point of Christian faith and worship in all continents? Jehohanan ben Hagqol suffered the same fate as Jeshua ben Joseph, yet he was forgotten until by chance his tomb was discovered. To answer this question it is not enough to dwell on the brutal fact of Jesus' crucifixion. We need to examine how – throughout the centuries and across different cultures – Christian believers gradually discovered the manifold meanings of what happened that Friday noon.

The cross and the crucified Lord

There is still no satisfactory way of explaining why, until the fifth century, Christians did not portray Jesus on the cross. Of course, Christian art developed slowly on the whole. Most of the early Christians were too poor to commission any work of art. The Old Testament prohibition of images had its impact on the church and during the times of persecution it was dangerous even to draw the Christian cross mark. But from the early third century onwards Christians expressed their faith through graffiti, drawings and frescoes in the catacombs. There one finds many cross marks; Jesus is sometimes portrayed as the shepherd, as a child in the arms of Mary, as teacher and healer and as the host at the eucharist, but he never appears as the one on the cross. When at the beginning of the fourth century the persecutions ended, impressive Christian sarcophagi were sculptured. Sometimes they portray scenes from Christ's passion, often combined with representations of Old Testament figures such as Cain and Abel, or Abraham and Isaac. Frequently scenes from the martyrdom of Peter and Paul are added. Yet there are no representations of Christ's suffering such as the *ecce homo*, the scourging of Jesus or his crucifixion.

Was Christian spirituality so much centred on the resurrection and eternal life that representations of the crucifixion were unwanted? Hardly, for at the same time the Golgotha event had become the heart of eucharistic worship. Or was the crucifixion such an awesome event that for Christians of the third and fourth centuries it could only be recalled liturgically, through word and symbol in the eucharist, and not through artistic representation?

There is still another consideration. Enemies of the Christian faith apparently used the crucifixion event in their attacks on the church. A crude drawing scratched on a wall of an ancient Roman ruin on the Palatine, originating from about A.D. 200, shows a man looking up at a donkey hanging on the cross. The inscription reads: "Alexamenos worships god." This much-debated derisive crucifix may well be the very first known graphic representation of Christ's crucifixion. In the same building an inscription by another hand was found which reads: "Alexamenos is faithful." Was this the believer's answer to those who derided him? It is far from certain, however, that the derisive crucifix actually portrays Jesus: the drawing may equally well represent the Egyptian deity Typhon Seth or some other god in the form of a donkey. But there is no doubt about the identity of another figure on the cross, found on Egyptian gems which probably date from the third century. The naked man there is explicitly named Jesus, and from the text inscribed on at least one of the gems it is clear that this portrayal was used for magic purposes.

The earliest Christian artistic representations of the scene at Golgotha were probably made in Palestine. According to an old tradition it was Helena, the mother of the emperor Constantine, who found the cross of Jesus at Golgotha and in A.D. 335 consecrated the first basilica built on the tomb. This fostered the development of the veneration of the cross. Pilgrims came to the Holy Land and artefacts were made. For instance, some of the Palestinian pilgrim flasks of the fifth and sixth centuries portray the whole scene at Golgotha. The crucifixion of the two rebels is realistically shown, but the cross in the centre remains empty and the Lord, already risen, appears above this cross.

In the West the earliest Christian representations of Christ's crucifixion date from around A.D. 430. On an ivory tablet the crucified Lord is portrayed as a stout and beardless young man (*Plate IIa*). The crucifixion is also carved on one of the 28 small wood reliefs on the doors of Santa Sabina in Rome (*Plate IIb*). Here, the significance of the event is emphasized by the "perspective of importance": the crucified Lord towers over the much smaller rebels to his left and right. No suffering is visible. The representation on the ivory tablet shows that Jesus went to the cross on his own initiative and with his eyes open. His meaningful death is placed over against Judas' meaningless death of desperation.

In these two earliest Christian artistic interpretations the crucifixion remains simply one of the many scenes of the passion and resurrection narratives. In similar context it appears in illustrated manuscripts of the Bible and prayer books. The oldest painted book illustration of the crucifixion found so far is that in the gospel book of the monk Rabula in Zagbar, East Syria, dating from the year 586. It shows on the same page many details of both the events of Good Friday and Easter morning (*Plate III*). This narrative passion art continued throughout the centuries.

Especially in the western church, another trend began to develop from the ninth century: Christ is shown alone on the cross. Both the rebels who were crucified with him and the figures under the cross disappear. The devotion begins to centre exclusively on Christ's sacrificial death.

This is movingly expressed on a double page of the prayer book of Charles the Bald, painted around 850. On the left side one sees the emperor on his knees, addressing the following prayer to the crucified Lord: "O Christ, who at the cross became the atonement for all the offences of this world, forgive me my sins, too, I pray." On the right side Christ leans from the cross towards the royal penitent. From heaven God's hand brings down the crown of glory on the head of Christ and the victory of the cross is now being internalized and interpreted in terms of the expiation of sins.

By these ways, in the western church at least, the

event at Golgotha gradually became the centre of both the cosmos and the history of salvation.

A Carolingian ivory relief of the early ninth century shows this centrality of the crucified Lord (*Plate IV*). The classic symbols of the sun and the moon are in the top corners, but now the figures of the ocean and the earth have also been added in the corners at the bottom. In between them sits a person looking up to the Lord on the cross: some interpret it as a sibyl, others as the prophet Hosea. Scenes of the resurrection of the dead and of Christ's empty tomb illustrate the victory won on the cross. The snake which is mortally wounded squirms in its agony under the cross, while above it angels are sent by God's hand to serve the one who gave his life-blood for the eucharist. The church, symbolized by the figure of Ecclesia, appears twice. Under the cross she receives the blood of Jesus in the cup, and on the right side at the entrance of the temple she claims the place and the royal symbols of the dethroned figure of the synagogue.

As medieval worship and piety in the West concentrated on Christ's sacrificial death, the crucifix came to the fore. Already in the sixth and seventh centuries, pilgrims had brought back from Palestine small pectoral crosses with the figure of Christ in relief. There must also have been an indirect influence from Coptic art on early Christian art in the North. A Frankish gravestone consists of two quadrangles, the one on the bottom enclosing an oblique cross which indicates the four directions of the cosmos, and a superimposed smaller quadrangle containing a Greek cross with the crucified Lord in relief (*Plate V*).

Gradually such engraved reliefs of Christ on the cross developed into full sculptures, first on small processional and altar crosses. Then the crucifix became life-sized or even larger and served as receptacle for relics and the consecrated wafers of the eucharist, or simply as a statue of devotion. Early protest at such large sculptures later mellowed into appreciation of their value for meditating on the passion of Christ.

The most famous and at the same time the oldest preserved large crucifix is the Gero-Cross in the Cathedral of Cologne (*Plate VI*), an oakwood sculpture created around A.D. 965 which for the first time represents the event at Golgotha with full realism. The heavy body of Jesus hangs distorted on his outstretched arms and his eyes are closed. Nevertheless, it is not the outward pain of Christ which makes him so deeply moving, but rather the inner suffering which shows on his face.

In the eastern church the crucifixion event was never given such a central place in worship and art. Christ is portrayed more as the majestic Pantocrator on the heavenly throne, just as on ancient sarcophagi the cross appears as essentially the sign of victory and glory.

Consequently, when Byzantine art was continued and further developed in Orthodox iconography the emphasis lay not on the crucifixion, but on the transfiguration. In fact, each monk who devoted his life to painting icons had to begin his sacred art by copying the icon of transfiguration, for – as the iconographic canon prescribes – he had to learn to paint with light and not with colours. In the special technique of icon painting the light shines through from within and behind the persons and objects depicted so that there is no shadow. This emphasis on the transfiguration of all human and earthly realities is also helped by the inverted perspective: the persons and objects are not painted from the point of view of the artist and the onlooker, but from God's point of view above and behind the icon. This helps the icon take hold of the onlooker and draw him or her into the process of transfiguration.

This special emphasis also characterizes the icon of the crucifixion. Christ's suffering is transfigured and manifests the incomprehensible love of God. Whoever meditates on this icon is drawn into worshipping God.

It is legitimate to speak about *the* icon of crucifixion, for ever since the iconographic canon was accepted by the synod of Trulla/Constantinople in A.D. 692 – it was reconfirmed by the synod of Moscow in A.D. 1551 – the tradition of icon painting has remained unchanged throughout the centuries, in both form and content, with minor local variations. However, as with other icons, so also the one of the crucifixion has a prehistory in Syrian and Byzantine art. In the painting of the Rabula-codex described earlier (*Plate III*), some of the basic features of the later icon appear already. Yet that Syrian book illustration of the sixth century shows so many persons and episodes that its character remains narrative rather than meditative. Gradually the secondary figures and scenes were left aside. The cross of Christ was elevated so that it reached up into heaven. Finally the gold shining through the transparent layers of paint made even out of crucifixion an event of transfiguration.

Intermediary phases of this development can be observed quite clearly in a series of three crucifixion icons of the eighth and ninth centuries in the monastery of St Catherine on Mount Sinai. The first of these still represents the rebels who were crucified with Jesus, although they appear only on a small scale in the background. They are almost hidden at the edges of the second icon, and on the third one

only Mary and John are seen under the cross, looking in deep meditation up to the one who by his obedience unto death has fully manifested God's love. This vision of the crucifixion emphasizes neither the triumphal victory of the cross, as the early Christian passion art does, nor the suffering of the death struggle, as seen in the late western medieval art. Rather, the icon interprets the deep peace won by the self-sacrifice of Christ, who is represented as if he were sleeping on the cross.

Later Byzantine mosaics accentuated the symbolism of this redeeming death. On a crucifixion mosaic at Daphni (second half of the 11th century) the blood of the new Adam flows on the skull of the first Adam, buried under the cross, and the hill of Golgotha begins to blossom like the mountain of Paradise. The body of Christ already appears in the same posture as in the later Russian icons, giving it an ethereal aspect. This almost floating position of the elongated figure of Christ is the major characteristic of the most famous crucifixion icon, painted around A.D. 1500 by Master Dionisi of Moscow, or by someone of his school (*Plate VII*). The cross reaches up far above the walls of Jerusalem, but at the same time it is firmly rooted in the rocks of Golgotha. It even breaks open the dark cave of the reign of death where the skull of Adam is buried. Yet the gold shines through the rocks and Golgotha becomes Tabor, the mountain of transfiguration. Under the outstretched arms of Christ one sees two mysterious figures gliding together with angels in the space of heaven, symbolizing perhaps the Ecclesia and the Synagogue, or Adam and Eve who have already been liberated from death.

In the western church the nearest parallel to this eastern icon of the crucifixion is the Romanesque crucifix. These wood sculptures from the late 11th to the early 13th centuries invite the onlooker to prayer and meditation. While the icon has the cross reaching up to heaven, in the Romanesque cathedrals the crucifix is set high up in the nave of the church. In the icon, gold shines through, to symbolize the glory of Christ on the cross; the majesty of the Romanesque crucifix is symbolized by the absence of the crown of thorns which sometimes is even replaced by the imperial crown. The suffering which the victory of the cross implied is not hidden. Yet the unknown artists of the Romanesque period portrayed this agony much less realistically than did the master of the Gero-Cross of Cologne, described earlier. They simplified the form and spiritualized the facial expression. In their interpretation of the cross the main accent lies on the peace and salvation wrought by Christ's sacrifice, as they appear in the posture and expression of a Spanish Christ of that period (*Plate VIII*).

From the beginning of the 13th century a new trend can be observed in western artists' interpretation of Golgotha. While in the Romanesque period Jesus is enthroned in an elevated position, sometimes with eyes wide open and clothed in a tunic or an ample loin-cloth, the typical crucifix of the Gothic period shows him as almost naked, with eyes closed and often situated very near the worshippers, down on earth. Now for the first time in Christian passion art the cruel suffering of Jesus, his agony and death are not only realistically portrayed but actually emphasized. The crown of thorns is brutally forced on the head of Christ.

Why this change of emphasis? It reflects the mood and spirituality of the late European Middle Ages. In the Christian Orient the crusaders had seen figures of the dead Christ on the cross with closed eyes. The use of this symbol for physical death was dictated by theological motives in the East. The early Byzantine over-emphasis on Christ's victory and glory had misled many eastern Christians into minimizing or even denying the humanity of Christ. This heresy was defeated in the great dogmatic debates of the fifth to the seventh centuries and the artists began to portray the Orthodox understanding of Christ with both a human and divine nature. So they depicted both the dead Christ on the cross and the eternally living Pantocrator on his throne of glory. The crusaders may not have understood much of this dogmatic symbolism, but the portrayal of the dead Christ corresponded to their own experience of suffering and death through pestilence and war. Moreover, a keen sense of sin and penitence led to the emphasis on the cost of salvation and therefore to the realistic portrayal of the Saviour's agony.

The Gothic crucifix, then, no longer inspires peace and quiet meditation: the worshipper is challenged emotionally to participate in the drama of redemption. Thus the crucifix of the Naumburg Cathedral hangs on the post in the middle of the door leading to the altar: there is no way to the altar and to atonement except by passing under the arms of Christ on the cross. Just as the late medieval mystics dwelt on the redeeming sufferings of Christ, so the artists of that time invited the worshippers to a mysticism of suffering. The "Devout Christ of Perpignan" is portrayed at the moment of his death cry (*Plate IX*) where the whole suffering humanity can find at-one-ness with God. His distorted face is like a mirror of the agony of all times.

While these Gothic sculptures evoke the response of the onlookers, painters in Italy began to depict this human participation in the passion events. Mary of Magdala, the representative of sinful humanity, is painted kneeling under the cross and with deep emotion touching the feet of Christ. More and more persons appear, including kings and queens from the late Middle Ages, saints and the donors of the

painting. Sometimes the attention centres more on the emotions of those under the cross than on Christ himself. Moreover, the other dramatic scenes from the passion story are now portrayed, up to the entombment.

A painting by the Flemish artist Hans Memling announces a new change in western passion art. Created in 1470, the year which some historians consider to be the beginning of the Renaissance, Memling's canvas depicts a whole passion play (*Plate X*). The setting is no more the celestial world of the Byzantine and Russian icons than a cathedral as in the medieval passion art. Jesus' passion takes place in a late medieval town whose streets, palaces and gates are drawn with the new perspective of the Renaissance. Outside the town there is no longer a background of gold nor the blue of heaven, but a landscape with only little space for the sky. The accent in Memling's interpretation lies totally on the story. One can actually follow Jesus from the moment of his entry into Jerusalem through all the passion scenes to the crucifixion – painted in miniature on the horizon where the sky is dark – and from there to the entombment and the resurrection. Jesus is no longer surrounded by a halo. He is a man like others, just as in the late medieval passion plays the divine Son was played by a human actor.

Through these passion plays the painters and sculptors of the Renaissance finally had models for their crucifixion scenes. The anatomy of the human body before and after death was now carefully observed, and shockingly realistic crucifixions were painted such as that of Matthias Grünewald for the altar at Isenheim – a fully Gothic representation of Golgotha, possibly a conscious protest against the passion art of the Italian Renaissance. During the Middle Ages and also for Grünewald, Christ on the cross was the incarnate *God*. For the artists of the Renaissance, however, Christ became more and more the divine *man* who heroically suffered death and who even in his dying remains beautiful. Then subjects other than the crucifixion became central; it is symptomatic that among the most famous masterpieces of both Leonardo da Vinci and Michelangelo there is no single sculpture or painting of the crucifixion. Other subjects were now attracting the attention of the greatest artists.

In the countries of the Reformation no deep passion art could develop at first. Radical movements even led to the destruction of precious medieval sculptures and paintings. John Calvin acknowledged the visual arts as a gift of God, but he saw no place for this art in the church. Martin Luther welcomed and encouraged art for Bible illustration and didactic purposes, and his friend and collaborator Lucas Cranach painted many crucifixion scenes. Using symbolism of the late medieval passion art, Cranach paints the story of crucifixion and pictorially explains its meaning, as if he were preaching a sermon on a biblical text. These paintings are therefore illustrations of the *word* of the cross rather than new artistic interpretations of this word.

It was during the Baroque period in the 17th century that the theme of the crucifixion once again evoked great artistic interpretations, especially in Spain. Among them there are such masterpieces as the crucifix of 1631–32 by Velazquez (*Plate XI*) which, like medieval sculptures or icons before it, leads the onlooker to meditate on what happened at Golgotha.

Two decades later the Protestant artist Rembrandt became a true painter of the cross. Reflecting on the biblical testimony to Christ, he saw ever clearer that the divine light falls not on human beauty, strength and glory, but on man in his misery. In the several versions of the crucifixion etching (*Plate XII*) it is clear how Rembrandt struggled with this insight, letting darkness increasingly swallow up all human glory and letting the light from above fall only on Christ on the cross and those who believe in him.

The cross in the modern western world

There is a strange unevenness in western artistic interpretations of what happened at Golgotha. Although in the first part of the 18th century Johann Sebastian Bach composed the great passion oratorios, there were no more significant interpretations of the crucifixion in the visual arts after the Baroque era and the time of Rembrandt. The "Cross in the Mountain", painted by Kaspar Friedrich at the beginning of the 19th century, has been greatly admired for generations. Eugène Delacroix has a Golgotha scene among his many dramatic canvases, and towards the end of the 19th century Paul Gauguin painted his "Yellow Christ" (*Plate XIII*), set in the landscape of Brittany. But these are isolated works, and the crucifixion never became the major theme of any of the great European painters or sculptors of the 18th and 19th centuries.

However, many artists of the end of the 19th and the first half of the 20th century felt deeply the brokenness of the modern world, the superficiality and selfishness of western civilization which twice in a century led to the agony of world war. In Vincent van Gogh's last paintings and in Picasso's "Guernica" the crucified Jesus does not appear, but the interpretation of the anguish of human life and war in these masterpieces comes nearer to the significance of Golgotha than most "religious art" of their time. This prophetic interpretation of the sickness of modern western civilization led in both Europe and North America to the breaking apart of forms. The persons portrayed are shown in one and the same painting from different perspectives or appear in different phases of movement. Much of this modern abstract art can be looked at in the light of crucifixion. Here the interpretative process happens much more within the observer than the creating artist, something which many modern artists actually want to provoke.

Several great artists of the 20th century have again taken up the theme of crucifixion itself. In a study for a chapel in Vence, France, Henri Matisse created a crucifix of utmost simplicity. Fritz König's sculpture "Golgotha" shows the crucified Lord rising above Golgotha. The place is formed not of rocks, but of a group of human bodies. Graham Sutherland paints Christ in the style of a modern Grünewald. In several drawings of Pablo Picasso, Jesus on the cross appears in the context of the Spanish bull-fight. These are but a few examples of the Golgotha event being seen again as a key to the human predicament. For some of these artists Christ on the cross has become a major theme – the North American William Congdon, for example (*Plate XIV*). Even more so, the works of Marc Chagall and Georges Rouault show how deeply relevant and revealing Christ's death is for those who see beyond the surface of life in modern Europe and North America. As reproductions of Chagall's and Rouault's works are easily available, none of them appears in this book, but it is important to reflect on their interpretations of Golgotha.

In more than twenty of Chagall's paintings, lithographs and gouaches, Jesus on the cross appears as the main figure. Several of them are actually entitled "Crucifixion". On many other canvases the crucified Jesus becomes a secondary symbol. This is all the more astonishing because Chagall – though not an Orthodox Jewish believer – remains strongly rooted in the Old Testament and in his background of Russian Jewish mysticism.

In the early cubist painting "Golgotha" of 1912, Jesus is portrayed like a child, taken up to the cross out of the arms of his mother and father below. Chagall himself later explained that with this painting he wanted to show Christ as the child whose inexplicable suffering contains hope because it is the suffering of an innocent.

After this early painting the events at Golgotha did not appear for a long time in Chagall's work. Then the famous "White Crucifixion" was painted in 1938: in the background an invading army, a burning synagogue and a village upside-down; in the foreground Jews on the run, attempting to escape the persecution. In the middle of this apocalyptic scene Jesus hangs on an oblique cross, clearly identified not only by the inscription "INRI", but also by the translation into Hebrew: "Jesus the Nazarean, King of the Jews." At the bottom of the cross stands the Jewish candelabra and beside it a Jew carries the Torah scroll to safety.

Who is this crucified Jesus? In a triptych called "Resistance – Resurrection – Liberation", a man on the cross and a Jew holding the Torah are placed in the centre. This 1948 painting reproduced the main structure of an earlier painting called "Revolution" which Chagall made in 1937 but later destroyed because of his disappointment with revolutionary movements. A coloured draft of "Revolution" which has been preserved shows in the central part the Jew with the Torah and a man with the features of Lenin doing a handstand on a table, fascinating the crowd with his speech and acrobatics. Why did Chagall replace the revolutionary leader with the man on the cross? And why did he entitle the central image of the 1948 triptych "Resurrection" and not "Crucifixion"?

It would be wrong to interpret Chagall's crucifixions simply in the light of the New Testament message and the Christian dogma. Nor is Jesus simply a symbol for general human suffering. The man on the cross is for Chagall Jesus the Jew and as such the representative of the suffering Jewish people, like the suffering servant of Isaiah 53. In a painting called "The Martyr" (1940) the victim is clearly not Jesus of Nazareth but a 20th century Jew

in Russia. Similarly in a gouache of 1944 three crucified Jews appear in the street of a Russian village. All these paintings are not images of despair. The suffering servants – be they the crucified Jesus of Nazareth or the murdered Jewish people in the 20th century – suffer vicariously. In the midst of apocalyptic scenes, therefore, one discovers symbols of hope and joy: the light which falls from above, the angel with the trumpet announcing not only judgment but also coming peace, the light of candles, the music of the violinist, the grace of young women, the care of the mother, the ladder leading up to heaven and always the consolation and promise coming from the Torah, the Jewish Scriptures. Many of these symbols appear in Chagall's "Crucifixion in Yellow" (1943).

Chagall's Jewish interpretation of the crucifixion finds many echoes in Rouault's Christian interpretation. There is the same apocalyptic background of war, the same sensitivity to human misery and the same deep identification of the crucified Christ with those who suffer today. Yet Rouault recalls not only the persecuted Jews, but suffering and humiliated men and women in general – clowns and prostitutes, exploited factory workers and dying soldiers. Within and behind them all Rouault discerns the presence of Christ, the Christ in agony. "Deep down inside the most unfriendly, unpleasant or impure creature Jesus dwells," he once wrote. In another context he confessed: "I believe in Jesus on the cross." One plate of his famous series "Miserere" carries the comment taken from Blaise Pascal's meditation on the mystery of Jesus: "Jesus will be in agony even to the end of the world."

No sentence could better characterize Rouault's passion art. Jesus on the cross is present and continues to suffer when the downtrodden are being judged by the powerful and wherever a human being lies in agony. This man of sorrow on the cross in Rouault's paintings recapitulates many of the deepest trends in the artistic interpretation of what happened on that Friday noon at Golgotha. Rouault, like Rembrandt, points to the incomprehensible love of God in the midst of the ugly, the poor and the despised, thus protesting against the superficiality of the "religious art" of his time.

Rouault was apprenticed as a glass-painter. In his paintings the colours burn like fire through the black contours of the figures, just as in a medieval glass window, yet now these colours do not symbolize the fire of hell and the light of heaven beyond our time and space, but hell and heaven in the midst of everyday life.

Like the Romanesque crucified Lord, Rouault's Christ stands before us as if hewn out of stone, with ever more simplified features and a serious compassionate face. Yet now this Lord is not elevated, high up in the nave of a cathedral – he stands in the midst of human misery.

Rouault was once called "the last painter of Christian icons"; and, like an icon painter, he has repeated the one message with ever-changing nuances and translated it into colours. But no gold is used and the message is not so concerned with the transfiguration of everything on earth into the glory of heaven. Rouault rather reiterates the conviction that God cannot be found except in suffering and that there is no resurrection without the cross.

Chagall's and Rouault's Jesus on the cross are typical of the major emphasis of contemporary artistic interpretations of the cross in the modern West. Jesus is met in everyday life. In North America during the civil rights movement and the Vietnam war, many new verses were added to the lyrics of traditional black spirituals. "Were you there when they crucified my Lord?" Not only "when they nailed him on the cross", "when the sun refused to shine", "when they laid him in the tomb", but also "Were you there when they bombed a house at night?", "Were you there when they turned away the poor?", "Were you there when they burned a land with bombs?"

As the one whose presence is discerned among those who suffer and whose death gives hope, the crucified Jesus continues to challenge a new generation of artists, whether they be confessing Christians or not. Thus a young student of arts, Paul Le Grand, made a sequence of drawings on the cross in the asphalt-jungle (*Plate XV*). There is almost no space for the cross in the streets of the inner city. Nobody seems to notice the one who was crucified or the blood which flows. Nevertheless, this blood finally covers the whole picture. At the end nothing seems to have changed, yet everything is changed from black to red.

Throughout the centuries what happened on that Friday noon at Golgotha has been reinterpreted by artists for their own time and culture. In retracing the developments of this continuing interpretation we have so far remained within the circle of those cultures which, through their languages, symbolism and history, have direct links with the early church and the ancient Mediterranean world. However, the crucified and risen Christ is not bound to that limited circle of cultures. He has crossed not only barriers of time, but also barriers of continents, languages and cultures. How is the meaning of his death understood, interpreted and confessed in Latin America, Asia and Africa?

The cross in Latin America

Latin America stands mid-way between the world of eastern and western Christendom on the one side and the cultures of Asia and Africa on the other. Its dominant languages remain European – Spanish and Portuguese. The highly developed ancient Indian cultures of Central America and the northern parts of South America continue to mark the thought and life-styles of the Indian-American section of the population, and throughout Latin America strong elements of African cultures characterize the Afro-Americans of that vast continent. Yet there is no doubt that the main uniting impact has come from the culture of the Ibero-Americans, not least the Spanish and Portuguese form of Catholic religiosity and a value-system and style of life strongly marked by southern Europe. With regard to artistic expressions this means that the pathos of the Baroque style, so typical of the Iberian art of that period, predominates.

It would be wrong, however, to separate these ethnic and cultural groupings too neatly, quite apart from the fact that still another separation is perhaps more important and more typical of Latin America today: the social division between the culture of the rich minorities and that of the poor who form the vast majority of the population. Yet even more characteristic is the intermingling of groups and cultures. Just as the conquering Spaniards and Portuguese married with Indian and African women, so the dominating Iberian culture has absorbed much of the culture of Indian- and Afro-Americans as well as the culture of the poor. This becomes manifest also in Latin American passion art.

The Iberian crown and the cross arrived together in Latin America in what has been called "the last of the crusades". Priests kept pace with the 16th century *conquistadores*, and it must have been very difficult for the native population to make any distinction between the sword and the cross. When in Peru captain Pizarro and his armed troops confronted the defeated great Inca Atahualpa, it was a Dominican friar who approached the Indian monarch with a cross in his right hand and a Bible in the left. After a summary sermon the emperor had to choose between conversion to Christ and submission to the Spanish crown or death. The Inca proudly refused to submit to any king or betray his allegiance to the sun-god by worshipping a god who had died on a cross.

Nevertheless, Latin America now stands under the sign of the cross. How is its significance understood? In the Andean regions consecrated crosses have been found which bear the pre-Columbian symbols of the sun and the moon on either side. The old and the new faiths have intermingled to an extent which is not common in other areas of the world. A striking example of this is provided by old crosses from Mexico, where the Christian symbol is decorated not only by the pre-Columbian sun and moon, but also by the old Mexican symbols of fertility.

In Mexico two faiths met, both of which emphasized blood and death. According to an old Mexican belief, death is the germ of life. The sun must be fed with blood so that again and again it can overcome the night. This dual conception of life and death appears in an ancient pre-Columbian sculpture where the right side of a very much alive human face is contrasted with the left side of the same head showing the dead skull. Among the Aztecs especially, human sacrifice and the worship of life through death played an important role. Into this culture came the Spanish conquerors who had been deeply marked by a constant remembrance of death, namely the European *danse macabre* which led man ultimately to either heaven or hell. They were obsessed by the cross and the bleeding Christ in whose blood was salvation. During the conquest the Aztecs were encountered with this typical Spanish Christ, described by Unamuno as "the purple, livid, blood-stained and blood-drained . . . exsanguinous Christ".

No wonder that the two so different and at the same time similar expressions of faith intermingled. The imported Spanish Christ was copied by Indian artists who used their own material and techniques, such as modelling with maize pasta. This was used to make the 16th century crucifix in the church of Saint Francis in La Antigua, Guatemala (*Plate XVI*). Such copies of the Spanish Christ soon assimilated older symbols of the pre-colonial time and gradually became "the other Spanish Christ".

During the centuries after the Iberian conquest, popular piety continued to be centred on the Spanish Christ with his mother Mary and the saints, strongly fused with ancient Indian-American and African deities. Even today, this crucifix plays a large role in Latin American folk-art: an appealing example is the plaited straw crucifix on sale in Mexican markets. Yet alongside this piety went an increasing estrangement from the Iberian church. Many of the great thinkers, writers and artists who inspired the Latin American independence movements and revolutions rejected the cross along with the crown.

It is no wonder that, as in Europe and North America, there was little development of any great passion art in Latin America during the 18th and 19th centuries. Today, however, the crucifixion again plays a central role. For many, and by no means only for Christians, Jesus on the cross has become a realistic symbol of hope, a clue to understanding what happens in the struggle for freedom and justice.

It is still very much the suffering Christ, a new version of the Gothic and Baroque art, which present-day Latin American painters and sculptors portray. Thus the Mexican artist Gonzalo Ceja has

several times painted the dying Christ. One of his canvases depicts the face of Jesus as a death mask with a glassy stare in the eyes and facial features which are already partly decomposed. Another of Ceja's paintings emphasizes a large nail on which the whole body of Jesus hangs (*Plate XVII*). The "Devout Christ of Perpignan" (*Plate IX*) comes to mind when contemplating the Jesus which the Peruvian Indian artist Edilberto Merida has modelled in clay and then nailed through enormous hands and feet on to a wooden cross (*Plate XVIII*). Merida's Jesus cries out like the Christ of Perpignan, yet this man on the cross is not devout. He does not humbly accept suffering; his agony is the last phase of a struggle. He looks rather like a guerrilla fighter being executed. It is not by chance that a reproduction of this crucifix appears on the front cover of one of the most famous contemporary Latin American theological books, *A Theology of Liberation* by Gustavo Gutiérrez. Liberation has its price. The exodus does not lead directly into the promised land, but into the testing of the desert. The cost of liberation is nothing less than the cross and the way to resurrection leads through Golgotha. There is no more realistic sign of hope than the cross.

What, then, are the main characteristics of Jesus on the cross in present-day Latin America?

First of all, he is a political Christ. He stands on the side of the poor and exploited. This is a favoured theme of several Latin American cartoonists, for instance the Brazilian Claudius Ceccon who shows how the fat and powerful ignore the cross, be they politicians, military or clerics. Similarly, the Mexican Rolando Zapata, in his scene at Golgotha, contrasts the brutal power of police terror with the power of love and innocence. The cross is not visible, but the presence of the crucified Jesus has been discerned by a little child (*Plate XIX*). The suffering country of Chile has been drawn in the form of someone nailed on the cross, and in a song by the Uruguayan poet Daniel Viglietti the death of Camilo Torres is seen in the light of the Golgotha event: "In the place where Camilo fell there grew a cross, not of wood but of light . . . They nailed him with bullets on a cross, they called him a bandit like they did Jesus." The crucified Lord is seen as the one who turns things upside down, the true revolutionary. In a painting by the Mexican muralist José Clemente Orozco, the risen Christ is even shown with an axe cutting down his own cross. For centuries in Latin America the cross was almost totally identified with the crown and the powerful. With similar exclusiveness many contemporary Latin Americans now link the crucified Jesus with those who struggle against the military power establishment.

Secondly, for those who are involved in this struggle for change and justice Jesus on the cross becomes the pioneer, the one who has preceded them into the torture chambers. He is the tortured Christ and therefore the brother of those who now suffer cruelly. No one has expressed this more strikingly than the Brazilian sculptor Guido Rocha. Suspected unjustly of being a member of a subversive group, he was tortured in Brazilian prisons. Only a few months before the military take-over in Chile he sought freedom in that country, where he was soon imprisoned again. Now he lives as a political refugee in Switzerland. During the cruel torture sessions in Brazil, when hovering between life and death, the person of the crucified Jesus gradually imposed himself on the artist. Since then he has modelled one tortured Christ after the other. Under the modelling fingers of Rocha the face of Jesus takes on quite unconsciously the features of one or the other of the artist's former fellow prisoners who died in the torture chambers. Rocha does not think of Jesus as the Son of God, the sacrifice offered for our sins or in any other such classic Christian dogmatic ways. "The characteristic of Christ is that his life was totally coherent, so coherent that the world could not stand him." This is what Rocha wrote under one of his sculptures of the tortured Christ (*Plate XX*). When crying out in pain Rocha remembered the cry of Jesus on the cross, and this cry of Golgotha became for him a great promise: here was a man who passed through the deepest sufferings and nevertheless remained fully human, fulfilling his mission of love, being a man for others, until the ultimate hour of truth. There was no gap between his message and his life and death. Therefore the almost unbearable face of the dying Christ, possessed, it seems, by evil spirits, is not an image of abhorrence for this Brazilian artist, but an image of hope.

These characteristics of Jesus on the cross in present-day Latin America are admittedly one-sided. Like all other artistic and dogmatic interpretations, they cannot express the whole mystery and meaning of Christ's death. However, they underline one of the earliest Christian understandings of the scandalous event of the crucifixion: Jesus had to suffer and be crucified because he was just. There is a divine "must" in the suffering of the truly righteous. The psalms of the righteous sufferer, especially Psalm 22, must have been foremost in the mind of Jesus on the cross. It was in the light of this psalm that the earliest church began to understand the meaning of what had happened on that Friday noon at Golgotha. For many Latin American Christians the righteous are those who suffer from oppression and struggle for justice. Therefore Jesus on the cross is very near to them.

The cross in Asia

In May 1498, Vasco da Gama's fleet landed on the Malabar coast in South India. On the deck of da Gama's ship stood twenty cannons and above them fluttered a flag emblazoned with a large cross of Christ. The Iberian conquest came to Asia as it came to Latin America. Yet here it met much more resistant indigenous cultures. Moreover, the crucified Lord himself had already preceded the would-be conquerors.

In Armenia, where Europe, the Middle East and Asia meet, the Christian church had survived despite its isolation after the Muslim conquest. The famous Armenian *khatchkars* – beautiful gravestones and monuments from the ninth and tenth centuries – are well preserved. They portray the cross with harmonious vignettes and great simplicity. After the 11th century the forms became more intricate with networks of botanical or geometrical engravings which recall the decorative art of Islam. Some of these *khatchkars* of the 13th century show Christ on the cross with wide-open eyes like the Romanesque crucifix, yet with a stronger head and a full beard (*Plate XXI*).

Even before these Armenian stone reliefs were sculptured the cross had appeared as a Christian sign at the very heart of Asia, in China. On the Sian-fu tablet of A.D. 781, an artfully written summary of Christian doctrine and a review of Chinese church history since the arrival of the Nestorian missionary Alopen are inscribed. Carved above this inscription appears what is undoubtedly the oldest Asian Christian cross. Just as in the case of the old western Christian sign of the jewelled and adorned cross, this Chinese cross does not recall the suffering but the lordship of Christ. The cross is set on the lotus (a typical Buddhist symbol), while issuing from under it are clouds – often associated in popular Taoism with the sages. Christ, the true sage, sits on the throne of Buddha! This is perhaps the challenging confession of faith which the artist of the Sian-fu tablet wanted to make.

Up to the 14th century, the symbols of the cross, lotus and cloud are found on many other Nestorian Christian monuments. Sometimes they are combined with figures of angels. It is doubtful, however, whether the Nestorians also carved or painted the crucified Jesus. For example, a report from the 13th century indicates that Nestorian Christians removed the figure of Jesus from a silver crucifix which Catholics had brought to China. And two centuries later Catholics also did not emphasize the event at Golgotha. The famous Jesuit pioneer missionary Matteo Ricci wrote in a letter dated 1585 that for China passion art was not desirable, and he hoped representations of the Christ in glory sitting on a throne would be sent from Europe.

The earliest Chinese portrayals of the crucifixion are probably those found on the so-called "Jesuit porcelain" of the 17th and 18th centuries where the whole set of a tea service and other pieces of porcelain were adorned with the crucifixion scene.

Meanwhile passion art had developed in other parts of Asia, notably on the Indian subcontinent. Except for two Persian crosses, going back to around the ninth century, no figurative art of the Syrian Christians on the Malabar coast is known. Either it was never created or it did not survive the hot and humid climate of South India. However, in the 16th and 17th centuries the crucifixion was painted in North India, not by Christians but by Muslim artists! Under the reign of the enlightened emperor Akbar the Great (1555–1605) and even more so under his art-loving son Jahangir (1605–1627), Indian Muslim artists were encouraged to copy and adapt western paintings. They preferred images of Mary and of the saints, but a few of their passion paintings have been preserved as well (*Plate XXII*).

While in North India Muslim artists painted crucifixion scenes, in Japan representations of Christ on the cross became the touchstone of Christian faith. After a promising beginning by Catholic missions in the 16th century, the propagation of the gospel was forbidden and in the early 17th century severe persecution of Christians started which lasted almost two hundred and fifty years. Japanese suspected of being Christian believers could escape cruel executions in only one way. An image with the figure of Christ, often the crucified Lord, was brought to them. If they stepped on this image and thereby renounced their faith they were set free. One such "stepping-image", a brass relief of the 17th century, shows the Golgotha scene in the style of European passion art, yet the facial expressions and the body stature of Jesus are those of a Japanese man with a pigtail. Believers who were faced with the decision of whether or not to step on this Christ learned in that fearful moment of truth more about the meaning of the crucifixion than many believers have found in a whole lifetime. Kimiko Koseki, a contemporary Japanese woman artist, has several times painted scenes of this moment of truth.

As one surveys present-day Asian art on Christian themes, several main characteristics of contemporary Asian interpretations of Golgotha emerge.

The crucifixion is represented relatively seldom. Among the many published Chinese drawings and paintings on New Testament themes Jesus appears most often in nativity scenes or as the teaching sage. Christ on the cross is not totally absent, however. Thus in the "Calvary" of Wang Su-Ta (*Plate XXIII*) the setting of Golgotha has become a typical Chinese landscape and not only Jesus but also the persons under the cross are Chinese. The artist contrasts the

fierce appearance of the soldiers with the attitude of devotion and sorrow of the believers, while the centurion sits on his horse like an ancient Chinese sage. In Japan and India there are more representations of the crucifixion but a comparatively large number of these drawings, paintings and sculptures simply transfer the classic European passion art to an Asian setting.

This does not mean that the events at Golgotha are not central in the faith and piety of Asian Christians. Enquiries both in India and Japan indicate the contrary. Yet the crucifixion has no parallels in classic Asian art and a new artistic interpretation for Asia of what happened at Golgotha is thus all the more difficult. This scarcity of Asian symbolism both for the fears and agonies of life and for self-giving love is certainly one reason why in the contemporary experience of suffering in Asian cities and villages more and more Asian artists are led to interpret the crucifixion. Among them one meets a surprisingly large number of non-Christians.

Sometimes typically Asian forms of artistic expression are used. As the form and content of an art work are intimately related, these typically Asian art forms can highlight new meanings of the crucifixion event. Thus Mirei Shigemori created a "Garden of the Cross", using the ancient Japanese art of stone gardens. Except for the shape of the cross formed by the arrangement of the rocks, this garden remains non-figurative and leads in a much deeper way to meditation on the meaning of Golgotha than many more literally descriptive paintings and sculptures of the crucifixion.

Gako Ota interprets the meaning of Christ's death with another ancient Japanese art form, that of flower arrangement. No flowers are used, but the world for which Christ died is symbolized by a tangle of dried up thorns and of iron wire, covered with some withered leaves. The oblique cross of Christ penetrates the whole tangle and upholds two other crosses, showing how Christ on the cross has fully identified himself with the suffering and death of the world.

The Indonesian batik painter Bagong Kussudiardja has created several crucifixion scenes where Christ is shown as a figure of the Javanese *wayang* theatre. In one of them (*Plate XXIV*), Bagong used the special possibilities of batik painting by letting daringly contrasting colours flow into one another. By this means the apocalyptic dimension of what happened at the crucifixion, the darkening of the sun and the shaking of the earth, is interpreted in a way never found in European art. Christ looks towards the new dawn at his right-hand side and – symbolizing the new exodus – he jumps from the cross.

In modern passion art from Asia two tendencies seem to hold together in tension. On the one side the crucified Lord appears as a divine figure, unmoved, untouched by all the sufferings and worries of this world. This is especially the case in the paintings of the Indian artists Alfred D. Thomas and Jamini Roy. Sometimes the Indian Christ is painted with a blue colour. This can indicate the heavenly, eternal nature of Christ just as in classic Indian art Lord Krishna appears with a blue body. However, this colour symbolism may also refer to the self-sacrifice of Christ, for the throat of the Hindu God Shiva became blue when he saved the world by drinking the poison of the cosmic sea.

This reference to Christ's self-sacrifice points to the second and more dominant trend, namely Christ's identification with the suffering of this world expressed, for instance, in Gako Ota's earlier mentioned "Three Crosses" and in the works of the Indian artists K. C. S. Paniker, Nandalal Bose, Nikhil Biswas and Shiavax Chavda. Suffering is much emphasized in the passion art of the Philippines, which still shows the strong impact of the Iberian conquest and the Spanish Christ. In the rest of Asia the accent lies more on the self-giving love of Christ. He is the one who stands for us between the threatening powers, as an impressive sculpture called "Reconciliation" by the Japanese artist Keiji Kosaka suggests. Here the small and seemingly weak Jesus holds apart two monsters or two waves breaking by standing in the form of the cross at the very place where the two will clash with one another (*Plate XXV*).

Perhaps the most original Asian contribution is the mystic interpretation of the crucifixion made by a Christian *guru* in Central Java/Indonesia. Having meditated deeply on the meaning of the cross this mystic teacher, who wishes to remain anonymous, has in half an hour of "holy ecstasy" created a large painted relief on the main wall of his living-room (*Plate XXVI*). The crucifixion of Christ stands in the centre of the meditation and teaching of this *guru*. On an outside wall of his house is a relief with Christ's head crowned with thorns, and for his prayer-room the *guru* has painted a crucified Jesus at the moment of his cry of agony.

The crucifixion relief on the wall of the living-room is full of Indonesian–Javanese symbolism. To the left of the cross one sees the star, symbolizing the first pillar of the Indonesian state doctrine, namely the *ketuhanan*, the "belief in God". The *guru* explains to his many visitors, mostly Muslim enquirers, that true belief in God can be found only at Golgotha, indicated by the largest point of the star. Above the cross hangs a figure from the Javanese *wayang* theatre, Kolobendono, well known to Javanese as the honest and faithful hero who gave his life for a friend. "But Christ gave his life for all," the *guru* reminds his visitors. The yellow dragon with the red

comb symbolizes the ferocious attack made on Christ by the conceit of power and glory. The struggle is not yet over, but further symbolism indicates that evil will not win. The left part of the cross beam is shorter than the right part, and in Javanese symbolism the right side indicates truth and goodness while the left stands for lies and falseness. The white of the loin-cloth symbolizes that the crucified Lord is the pure and holy one, and the black of his hair shows that he is the one who knows quiet and wisdom. The inscription on the cross is not the traditional INRI but the words "I myself" in Arabic Indonesian script. The *guru* wrote as an explanation to this: "A man who lives under the guidance of the Lord is able to suppress his own ego . . . in wisdom he submits to the word of the Lord and watches himself always with honesty and openness."

This openness and watching of oneself is expressed in a striking way through the open chest of Christ who watches his innermost being, now openly visible. The Indonesian word for "mysticism" means "what is innermost", "what is hidden", and mysticism teaches that those who want to seek salvation, wisdom and truth cannot find this secret in the macrocosm but only by turning to the innermost part of the microcosm, to their own self. Yet Christ has sacrificed his own self. His innermost being is open and vulnerable. In the explanation of his work, the *guru* wrote: "We find in Christ the model for life, and the crucifixion is the manifestation of the love for mankind."

Ancient Christian art found its way not only into Asia, but also into Africa, in this case not through Armenian and Syrian Christians but through Copts and Ethiopians. Unfortunately all the earliest Ethiopian Christian art has been destroyed or badly damaged. From the 14th and 15th centuries onwards, however, we have well-preserved Ethiopian representations of the crucifixion, especially painted book illustrations. Some portray the scene at Golgotha in the manner of early Byzantine art, with Christ on the cross between the two rebels, angels above and figures under the cross. Only the arabesques in the background reveal that these book illustrations were painted in another cultural milieu. In other manuscripts the victorious lamb of God appears above the central cross, which is empty (*Plate XXVII*).

This development towards symbolism and a typical African simplification of forms led in still other manuscripts to a portrayal of crucifixion where only the two rebels are drawn figuratively, while the mystery of Christ's crucifixion is interpreted through abstract, geometrical cross-lines. Ethiopia is also the country where the most varied forms of the cross have developed.

While these Ethiopian crosses and book illustrations were made in the north east of the continent, the gospel was first preached south of the Sahara in West Africa. Around 1484 Portuguese navigators had reached the coast of the Congo delta. They brought with them a missionary who remained in the small African kingdom of the Congo where the ruler encouraged contacts with the Portuguese though he himself never fully accepted Christianity. Then in 1492 the ruler's son Don Affonso succeeded to the throne. He had not only been baptized, but had fostered the Christianization of his country and attempted to create a copy of Portugal in the midst of black Africa. In 1518, Affonso's son was ordained bishop of the rapidly growing church. European religious art was sent as gifts from both the Pope and the royal family in Portugal. There is no evidence that any conscious effort was made to use original African cultural elements in interpreting the gospel. After the death of Affonso the European copy of a Christian society in the Congo gradually vanished, leaving little imprint on African culture. However, when in the 19th century Christian missionaries came back to that area they found not only church bells but also true African crucifixes of the 16th century. The gospel had apparently penetrated deeply enough into the villages to give rise to an indigenous African Christian art.

These old African crucifixes had been handed down from generation to generation long after the first church in the Congo had vanished. Probably they were used sometimes for magical purposes, but

nevertheless they are the first examples of a now rapidly developing African Christian art. These brass sculptures show the crucified Christ as an African with broad lips, protruding nipples and navel, often with African ornaments on the loin-cloth and sometimes with figures under the cross and on the cross-bar.

The Christian art of Africa displays a great emphasis on the cross. This is clearly expressed in the confessional poem by the South African Gabriel Setiloane entitled "I am an African". Asked what an African believes, Setiloane first reaffirms the faith of his forefathers who knew God under different names, such as Uvelingqaki or Unkulunkulu. This leads to a further question:

"Tell us further, you African: what of Jesus, the
 Christ,
Born in Bethlehem: Son of Man and Son of God
Do you believe in him?"
The answer is:
"For ages he eluded us, this Jesus of Bethlehem, Son
 of Man:
Going first to Asia and to Europe, and the western
 sphere . . .
Later on, he came, this Son of Man:
Like a child delayed he came to us.
The white man brought him.
He was pale, and not the sunburnt son of the desert.
As a child he came.

A wee little babe wrapped in swaddling clothes.
Ah, if only he had been little Moses, lying
Sun-scorched on the banks of the River of God
We would have recognized him.
He eludes us still, this Jesus, Son of Man.
His words: Ah, they taste so good
As sweet and refreshing as the sap of the palm
 raised and nourished on African soil.
The Truths of his words are for all men, for all time.

And yet for us it is when he is on the cross,
This Jesus of Nazareth, with holed hands
and open side, like a beast at a sacrifice;
When he is stripped naked like us,
Browned and sweating water and blood in the heat
 of the sun,
Yet silent,
That we cannot resist him.

How like us he is, this Jesus of Nazareth,
Beaten, tortured, imprisoned, spat upon,
 truncheoned,
Denied by his own, and chased like a thief in the
 night,
Despised, and rejected like a dog that has fleas,
for NO REASON.

No reason, but that he was Son of his Father,
OR . . . Was there a reason?
There was indeed . . .
As in that sheep or goat we offer in sacrifice,
Quiet and uncomplaining.
Its blood falling to the ground to cleanse it, as us:
And making peace between us and our fathers long
 passed away.
He is that LAMB!
His blood cleanses,
not only us,
not only the clan,
not only the tribe,
But all, all MANKIND:
Black and white and brown and red,
All mankind!
Ho! . . . Jesus, Lord, Son of Man and Son of God,
Make peace with your blood and sweat and suffering,
With God, UVELINGQAKI, UNKULUNKULU,
For the sins of mankind, our fathers and us,
That standing in the same sonship with all mankind
 and you,
Together with you, we can pray to him above:
FATHER FORGIVE."

That confessional poem and prayer gathers all the most important characteristics of the crucified Jesus in Africa.

In viewing and meditating on many examples of the sculptured African crucifix, one is first of all impressed by the deep humanity of the one on the cross. He is an African, burnt by the sun, almost naked, suffering. Yet this suffering is not emphasized as in the European Gothic passion art or in Latin America today. Just as Africans sing, dance and laugh in the midst of suffering, so Jesus appears almost smiling on the cross, in a crucifix sculptured by an unknown East African artist (*Plate XXVIII*). More often Christ is represented with great dignity, like a king incognito. The scene of Golgotha is cut into wood with simple lines and concentrated forms in a typical African relief from Nigeria (*Plate XXIX*). This simplicity of line is particularly appropriate for interpreting what happened on that Friday noon at Golgotha. The open eyes of Christ crucified are here not symbols of divinity or immortality. Rather, they show that just as today many Africans patiently continue to suffer, though they do not understand this suffering, so Jesus on the cross carries his suffering in full consciousness, not understanding God's will but nevertheless obeying it. It is this vision of Jesus which has probably inspired so many African artists to depict Christ carrying his cross.

The second main characteristic of modern African expression of the crucifixion is the emphasis on sacrifice. The blood of Christ cleanses the people and the earth. In the Fort Hall Memorial Cathedral for the martyrs of the Kenyan emergency, the

Tanzanian artist Elimo Njau made a fresco in which the sacrificial blood of Christ stains the hill of Golgotha. This particular interpretation of the death of Christ is even more impressively portrayed by the Ethiopian artist Gebre Kristos Desta. In an almost non-figurative painting, the crucified Lord appears as a large sacrificial victim with dots of blood around a dark background with crosses (*Plate XXX*).

The mysteries of suffering, life and death, the secret power of blood and sacrifice—these are the primary messages which many African believers discern in the crucifixion. The majestic Christ on the cross, painted by Engelbert Mveng from the Cameroun on the apse of a chapel in Douala, shows this clearly (*Plate XXXI*). Only three colours are used, which in West Africa denote suffering (black), death (white) and life (red). The crucified Lord, mainly painted in red, is shown on the black cross and he has taken up into himself the white of death. In the semi-circular apse his outstretched arms are not only raised but stretched forward, embracing the whole world, as if giving his benediction from the cross. African symbolism under the cross shows how at his feet the whole cosmos is gathered up, while under his arms people come together in one great family.

In another context Mveng has summed up his understanding of Christ in the following way, and this confession of faith also indicates his interpretation of the cross.

"The initiation rites of traditional religion demonstrate to man that he is a divided being, fragmented between life and death, that man himself is not an isolated being, but a living cell in a living body, namely in the human community. This living body is itself the heart of the cosmos, all the elements of which are, so to speak, an extension of the human body. Thus the destiny of man, the destiny of the human community and the destiny of the cosmos are bound up together. They constitute a common destiny, scarred by the same division and involved in the struggle between life and death. The initiation rites show man what life is, and what death is. They equip man for the struggle . . .

"In experiencing the encounter with Jesus Christ, the African welcomes Christ as son of God, the master of life and death, the one who, by his life, teaching, miracles, sufferings, death and resurrection, is for man the supreme master of initiation, the one who knows the final truth about the meaning of life and the meaning of death, the one who brings the final victory of life over death. In the second place, the African also encounters Christ as Son of Man, making himself one of us . . . In time and space Christ takes our flesh, speaks our language, shares our lot in all its concrete everyday experiences. It is precisely here, in this concrete experience, that he demonstrates his victory over death, by healing the sick, feeding the poor, raising the dead, pardoning sins and finally conquering death by his own death and resurrection.

"We respond to this Christ, who became our brother, as a family. We speak to him in our own language and he answers us; we welcome him with all that is best in our cultural heritage, our art, our music, our dances, our ornaments, our stored wisdom. We respond to Christ as a family; in other words, as a human community and as a cosmic community. In our confession of faith, in our worship, in the humble confession of our sins, and in our joy in the salvation held out to us in Christ, we bring, as it were, an offering in praise of God, not only with the voice of the human community but also with the voice of the cosmos."

Initiation into human and cosmic community has its price. The initiation master hangs on the tree as the Kenyan artist Samuel Wanjau shows in his striking sculpture (*Plate XXXII*).

The event and the interpretation

On a journey through nineteen centuries and four continents only a small selection of artistic interpretations of Christ's death can be presented. Many trends in the history of passion art have not been mentioned, for instance the important development of cross-trees in the later Middle Ages where Christ's cross is portrayed as the tree of life. Whole regions have had to be left out. Thus no examples are given of the interesting interpretations of the crucifixion in the modern Middle East, those in the art of the Caribbean and the crucifixes in the Pacific, especially the Melanesian region. Yet even such a limited selection shows the tremendous variety of interpretations.

At the end of this journey we must consider the basic questions on the continuous process of interpretation. Is it legitimate that a particular historical event be interpreted in such a diverse manner in different times and cultures? Jesus was a Jew. He died on a definite day and place – on a Friday noon, probably the 7th of April of the year A.D. 30, at Golgotha just outside the walls of ancient Jerusalem. Is it a betrayal of biblical truth, or is it a necessary and appropriate communication of this truth that the crucified Lord be later portrayed as a Roman emperor, as a white European in a medieval city, as a Japanese of the 17th century, as a Latin American freedom-fighter or as a black African?

Three things should be kept in mind when reflecting on these questions.

First, the process of interpretation had already started in the New Testament. Before the four evangelists wrote their accounts of the crucifixion, even before the apostle Paul and other early Christian witnesses proclaimed and taught the meaning of Christ's death, the disciples and the church of the first generation had begun to interpret the meaning of the shocking event on that Friday noon at Golgotha. They did so in the light of what they knew of Jesus' teaching and by seeking clues of understanding from the scriptures, the Old Testament. On the basis of the psalms of complaint and praise some emphasized the divine "must" of the cross, the fact that all righteous must suffer, but that they will be vindicated by God. Others looked at Golgotha much more in the light of apocalyptic expectations and saw in it the anticipated judgment, the decisive turn of the ages, the manifestation of God's presence and the new exodus. Still others began to understand something of the mysterious event of the cross while reading sacrificial texts in the Old Testament as well as the song of the suffering servant in Isaiah 53. Thus, even before the New Testament was written, a diversity of Christian interpretations of Golgotha had been fixed in oral tradition, creeds and hymns. On the basis of this differently accentuated tradition the apostle Paul, and

later the four evangelists, taught and proclaimed various meanings of Christ's death. As these pages show, not only the theologians but also the artists of the church have continued this process of interpretation for every new time and place. In almost all of their interpretations one can detect echoes and variations of this or that canonized biblical tradition.

Secondly, every sharp distinction between a historical event and its subsequent interpretation is wrong. It would of course be possible to describe the death of Jesus in the same way as one can now reconstruct the crucifixion of his contemporary, Jehohanan ben Hagqol, whose earthly remains were found in 1968. With such a description one might arouse archaeological interest and evoke sympathy. Yet this is precisely *not* the way in which the early church and the authors of the New Testament referred to what happened at Golgotha. They shared their experience of a Lord who, after his death, was risen and present with them in a mysterious way. The early church never forgot who Jesus had been and what he had said and done before his death. Considered in the light of his whole life on earth and his presence after death, the crucifixion of Jesus was a most mysterious event, laden with deep meanings which needed to be discovered, unfolded and expressed. In a very real sense the interpretations of the crucifixion belong, therefore, to the event of Golgotha.

However – and this is the third thing to keep in mind – not every interpretation of Christ's death remains true to what really happened and what this mysterious event really means. While in the early church there was much freedom to unfold ever new insights and nuances about the meaning of the cross, from the very beginning such new interpretations were checked with the yard-stick of the earliest biblical tradition. Later the church had to make a decision about what was a true and a false witness to the meaning of Christ's death. Thus the testimony given in the gospel of Peter, written in the second century, was rejected while the testimonies of Paul, the four evangelists and other witnesses were maintained. This process of discerning what is true and false witness must continue to accompany the ongoing process of interpretation.

What, then, in a given time and culture, is a true artistic interpretation of what happened on that Friday noon at Golgotha? No one can make this decision alone. Individual Christians and churches need one another's mutual support and correction. Some general criteria can nevertheless be established.

Every true artistic interpretation of Christ's death must first of all be good art. The sincere Christian belief of the artist does not guarantee the creation of good art. Nor is it sufficient for a true interpretation to represent Jesus simply with a European, an Asian

or an African face and to place Golgotha into the setting of another time and place. True art does not merely illustrate what happened. It must translate and interpret, it must make visible what is still invisible. Through visual symbols both old and new, artistic interpretations of the cross must evoke the deeper meanings of what happened at Golgotha.

This reference back to an historical event implies that every true artistic interpretation of the crucifixion has to be rooted in one of the many biblical traditions. Even for the artistic intuition there is no direct way back to the mysterious event of Jesus' death. Whether in a given time and culture the interpretation is to start from this or that Pauline, Markan, Johannine or other New Testament testimony to the crucified Lord, can only be decided in the concrete situation. Yet no new artistic interpretation of Christ's cross can be situated totally outside that biblical testimony.

It is not by chance that passion art had a slow beginning, both in the ancient church and in the so-called "younger churches" today. Apparently a period of "cultural asceticism" is needed for the church to become deeply rooted in the Christian tradition before Christian faith can be validly expressed by the artistic means and symbols of a new time and culture. So no great passion art that is really indigenous can be produced simply on commission. An artist must not only work on the subject of the crucifixion, but this subject must itself work, labour and shape the artist. Only then, out of an inner participation in the events of Golgotha, will new meanings of the mysterious crucifixion be discovered and be given shape.

The observation just made indicates where the most difficult and most important interpretation of Christ's death is to take place. All Christian art can only point to the true image of God which became manifest in Jesus Christ, not least when he was nailed on the cross. Yet there is a more existential way of making that image visible – by ourselves being transfigured into this "icon" of God which appeared in Christ, as the apostle Paul once wrote to the Corinthians (II Corinthians 3:18). The church itself is called to become God's artwork and the life of Christians is meant to be the continuous interpretation of the life, death and resurrection of Christ.

The last plate of these meditations under the cross emphasizes this fact. It shows an early Christian place of baptism (*Plate XXXIII*). Cut into the rock of a hilltop on the island of Rhodes lies a deep and large horizontal cross, formerly filled with water. Early on Easter morning new converts to the Christian faith were gathered there to be baptized. They had to step down into the cross and be symbolically buried in it, so that they might participate in the death and resurrection of Christ. Throughout the centuries and across all cultures this has remained the distinguishing mark of a truly Christian life: to share in the sufferings and the victory of Christ's cross.

Bibliography

This book has arisen out of a larger research project in which the following question was examined: What influence do different cultural settings have on the understanding of Jesus' crucifixion, both in New Testament times and in various cultural settings of today? The report of this research has been published in German: H. R. Weber, *Kreuz und Kultur: Deutungen der Kreuzigung Jesu im neutestamentlichen Kulturraum und in Kulturen der Gegenwart* (Geneva, 1975). An English translation of the exegetical part (chapters I–IV) of this study has been published under the title *The Cross: Tradition and Interpretation* (London/Grand Rapids, 1979). Chapter VI of the larger German report deals with the artistic interpretations of the crucifixion throughout the centuries and in various continents (text: pp. 143–185; footnotes: pp. 351–380). Extensive bibliographical references are given, and the most important of these are listed below.

GENERAL
Articles on Jehohanan ben Hagqol in *Israel Exploration Journal* XX (1970), pp. 18–58 – G. Schönermark, *Der Kruzifix in der bildenden Kunst*, Strasbourg, 1908 – H. Preuss, *Das Bild Christi im Wandel der Zeiten*, Leipzig, 1915 – H. W. Bähr, *Der Retter der Welt: Christusbildnisse aus zwei Jahrtausenden*, Tübingen, 1951 – J. Jobé, *Le Christ de tout le monde*, Lausanne/Paris, 1962 – O. Thulin, *Die Sprache der Christusbilder*, Berlin, 1962 – G. Schiller, *Ikonographie der christlichen Kunst, II: Die Passion Jesu Christi*, Gütersloh, 1968 – P. Hinz, *Deus Homo*, I, Berlin, 1973 – E. Kirschbaum, W. Braunfels (eds), *Lexikon der christlichen Ikonographie*, 8 volumes, Rome/Freiburg/Basel/Vienna, 1968–1976, articles on "Christus, Christusbild" (I, 355–454), "Kreuz, Kreuzigung . . ." (II, 562–656), "Kruzifixus" (II, 677–695).

ANCIENT CHURCH
H. von Campenhausen, "Die Passionssarkophage: Zur Geschichte eines altchristlichen Bildkreises", *Marburger Jahrbuch für Kunstwissenschaft*, V (1929), pp. 39–85 – F. Gerke, *Christus in der spätantiken Plastik*, Berlin, 1940 – K. Wessel, *Der Sieg über den Tod: die Passion Christi in der frühkirchlichen Kunst des Abendlandes*, Berlin, 1956 – Ph. Derchain, "Die älteste Darstellung des Gekreuzigten auf einer magischen Gemme des 3. (?) Jahrhunderts", in K. Wessel (ed.), *Christentum am Nil*, Recklinghausen, 1964, pp. 109–113 – E. Dinkler, *Signum Crucis: Aufsätze zum Neuen Testament und zur christlichen Archäologie*, Tübingen, 1967.

EASTERN CHURCH
A. Grillmeier, *Der Logos am Kreuz: zur christologischen Symbolik der älteren Kreuzigungsdarstellungen*, Munich, 1956 – K. Onasch, *Ikonen*, Gütersloh, 1961 – W. Nyssen, *Das Zeugnis des Bildes im frühen Byzanz*, Freiburg, 1962 – K. Wessel, "Zur Ikonographie der koptischen Kunst", in Wessel, *Christentum am Nil*, pp. 233–239 – P. Evdokimov, *L'art de l'Icône: théologie de la beauté*, Bruges, 1972 – M. V. Alpatov, *Early Russian Icon Painting*, Moscow, 1974.

WESTERN CHURCH
J. C. Aznar, *La pasión de Cristo en el arte español*, Madrid, 1949 – U. Engelmann, *Christus am Kreuz: Romanische Kruzifixe zwischen Bodensee und Donau*, Beuron, 1966 – R. Garaudy, *60 oeuvres qui annoncèrent le futur: sept siècles de peinture occidentale*, Geneva, 1974 – Monographs on the artists mentioned, especially W. A. Visser 't Hooft, *Rembrandt and the Gospel*, London, 1957.

MODERN WEST
P. R. Regamey, *Art sacré au XXe siècle?*, Paris, 1952 – F. Eversole (ed.), *Christian Faith and Contemporary Arts*, New York/Nashville, 1962 – Monographs on the artists mentioned, especially H. M. Rotermund, *Marc Chagall und die Bibel*, Lahr, 1970 – W. A. Dyrness, *Rouault: a Vision of Suffering and Salvation*, Grand Rapids, 1971 – W. Congdon, *Nel mio disco d'oro: itinerario a Cristo*, Assisi, 1961.

LATIN AMERICA
The author is not aware of any comprehensive study on Christian art in Latin America. In a recent symposium on images of Jesus in Latin America (J. Míguez Bonino a.o., *Jesus: ni vencido ni monarca celestial, imagenes de Jesucristo en America Latina*, Buenos Aires, 1977) the contribution by S. Trinidad touches on the subject (pp. 89–110) – J. A. Mackay, *The Other Spanish Christ*, London, 1932 – M. de Unamuno, "The Spanish Christ", in *Essays and Soliloquies*, New York, 1925 – *La muerta: expresiones mexicanas de un enigma*, Mexico, 1975.

ASIA
D. J. Fleming, *Heritage of Beauty*, New York, 1937 – Fleming, *Each With His Own Brush: Contemporary Christian Art in Asia and Africa*, New York, 1938 – Fleming, *Christian Symbols in a World Community*, New York, 1940 – Fleming, *Son of Man: Pictures and Carvings by Indian, African and Chinese Artists*, London, 1939 – G. Costantini, *L'art chrétien dans les missions*, Paris, 1949 – A. Lehmann, *Die Kunst der jungen Kirchen*, Berlin, 1955 – Lehmann, *Afroasiatische christliche Kunst*, Berlin, 1966 – *Christ in the Art of India/China/Japan/Philippines*, filmstrips and brochures, United Presbyterian Church, USA – M. Takenaka, *Christian Art in Asia*, Kyoto, 1975.

ARMENIA
L. Azarian, *Armenian Khatchkars*, Etchmiadzin/Lisbon, 1973.

CHINA
A. C. Moule, *Christians in China before the Year 1550*, London, 1930 – S. Schüller, *Die Geschichte der christlichen Kunst in China*, Berlin, 1940 – F. Bornemann, *Ars Sacra Pekinensis*, Mödling, 1950 – J. Foster, "Crosses and Angels from Fourteenth-century China", in *International Review of Mission* 44 (1955), pp. 170–174.

88

JAPAN

T. Nishimura, *Namban Art: Christian Art in Japan 1549–1639*, Kodansha, 1958– M. Takenaka, *Creation and Redemption through Japanese Art*, Osaka, 1966.

INDIA

F. zu Löwenstein, *Christliche Bilder in altindischer Malerei*, Munster, 1958 – R. W. Taylor, "Some Interpretations of Jesus in Indian Painting", in *Religion and Society* XVII/3 (1970), pp. 78–106 – Taylor, *Jesus in Indian Painting*, Madras, 1975.

AFRICA

Compare the books by Fleming, Costantini, Lehmann and the volume *Son of Man* listed under Asia – *Ethiopia: Illuminated Manuscripts*, UNESCO, 1961 – W. Korabiewicz, *The Ethiopian Cross*, Addis Ababa, 1973 – S. Schüller, "Christlich-afrikanische Kunst aus der ersten Kongo-Mission (15.–16. Jahrh.)", in *Die Katholischen Missionen* 65 (1937), pp. 34–40 – *Christ in the Art of Africa*, United Presbyterian Church, USA – P. Bruzzichelli (ed.), *Arte Africa e Cristo*, Assisi, 1963.

Origin of quotations

All texts from the Bible are quoted from The New English Bible, Second Edition © 1970, by permission of Oxford and Cambridge University Presses.

p. 2 (facing plate I):
"Vexilla regis prodeunt", Hymn to the holy Cross by Venantius Fortunatus (around 600). Original Latin version in F. J. E. Raby (ed.), *The Oxford Book of Medieval Latin Verse*, Clarendon Press, Oxford, 1970, No 55. English translation in *The Prayer of the Church*, interim version of the new Roman Breviary, Supplement III, London, 1970, pp. 140f. Reprinted by permission of Smurfit Educational Division, Dublin.

p. 8 (facing plate IV):
"Media Vita", attributed to Blessed Notker Balbulus (840–912). From the Latin by Frederick Rowland Marvin in Thomas Walsh, *The Catholic Anthology: the World's Great Catholic Poetry* (revised edition), Macmillan Publishing Co., New York, 1939, pp. 40f. Reprinted by permission.

p. 10 (facing plate V):
Quotation from Epistola VI/6 of Columban, Latin original and English translation in G. S. M. Walker (ed.), *Sancti Columbani Opera*, Dublin Institute for Advanced Studies, Dublin, 1957, pp. 30–33. Reprinted by permission – Irish hymn translated from original Latin text in *Analecta Hymnica Medii Aevi*, Leipzig, 1908, pp. 289f.

p. 14 (facing plate VII):
Translated from P. Evdokimov, *L'art de l'Icône: théologie de la beauté*, Desclée de Brouwer, Bruges, 1972, pp. 262f.

p. 16 (facing plate VIII):
Quotation from a sermon on Good Friday by Rupert of Deutz. Translated from original Latin text in *Patrologia Latina* 170, pp. 165f.

p. 18 (facing plate IX):
Translated from *Revelationes*, Lib I, by Saint Bridget.

p. 20 (facing plate X):
Quotations from V. A. Kolve, *The Play Called Corpus Christi*, Stanford University Press, Stanford, Ca., 1966, pp. 192f. Reprinted by permission.

p. 22 (facing plate XI):
Miguel de Unamuno, *El Cristo de Velazquez*, poema, Collección Austral, Buenos Aires/Mexico, 1947. English translation by Eleanor L. Turnbull, *The Christ of Velazquez* by Miguel de Unamuno, The Johns Hopkins University Press, Baltimore, 1951, pp. 3 and 119. Reprinted by permission.

p. 24 (facing plate XII):
Willem A. Visser 't Hooft, *Rembrandt and the Gospel,* SCM Press Ltd, London, 1957, pp. 115f. Reprinted by permission.

p. 26 (facing plate XIII):
Excerpt from the act of dedication written in 1895 by Saint Theresa of Lisieux. Translated from *Manuscrits autobiographiques de Sainte Thérèse de l'Enfant Jésus*, Office central de Lisieux, Lisieux, 1957, pp. 308f.

p. 28 (facing plate XIV):
Daniel Berrigan, *Consequences: Truth and . . .*, The Macmillan Company, New York, 1966, p. 31. Copyright 1965, 1967, by Daniel Berrigan, SJ. Reprinted by permission.

p. 30 (facing plate XV):
Dietrich Bonhoeffer, *Widerstand und Ergebung*, Munich, 1951, quoted from the English translation by Reginald Fuller and others, *Letters and Papers from Prison*, the enlarged edition edited by E. Bethge, SCM Press, London, 1971, pp. 337, 360, 361, 348f. Reprinted by permission.

p. 32 (facing plate XVI):
Crusaders' Song from Chronicle of the Dukes of Normandy (1145), in Thomas Walsh, *op. cit.*, pp. 54f. Reprinted by permission.

p. 34 (facing plate XVII):
Excerpts from the essay on *The Spanish Christ* by Miguel de Unamuno. Spanish original in Unamuno's *Ensayos* II, Madrid, 1964, pp. 391–395. English translation by J. E. Crawford Flitch in M. de Unamuno, *Essays and Soliloquies*, Alfred A. Knopf, Inc., New York, 1925, pp. 76–81. Reprinted by permission.

p. 36 (facing plate XVIII):
Translated from Ernesto Cardenal, *Salmos*, Universitad Antioquia, Columbia, n.d., Ps. 22.

p. 38 (facing plate XIX):
"Dijo ser rey" ("He said He was a king"), poem by an anonymous Christian political prisoner in the Chilean concentration camp of Chacabuco, written in February 1974 to the memory of the death of Camilo Torres on 15 February 1966. English translation in *Latinamerica Press* VI/44 (January 1975), p. 6. Reprinted by permission.

p. 40 (facing plate XX):
Continuation of the above Chilean poem.

p. 42 (facing plate XXI):
Excerpts from the liturgy of the Armenian Church. English translation from Peter D. Day, *Eastern Christian Liturgies: the Armenian, Coptic, Ethiopian and Syrian Rites*, Irish University Press, Shannon, 1972, pp. 47 and 62. Reprinted by permission.

p. 44 (facing plate XXII):
Both the text of Surah iv.156 and the beginning of Hussein's novel are quoted from the introduction and English translation by Kenneth Cragg; M. Kamel Hussein, *City of Wrong: a Friday in Jerusalem*, Djambatan N.V., Amsterdam/The Hague, 1959, pp. X and 3f. Reprinted by permission.

p. 46 (facing plate XXIII):
Prayer by a Chinese spokesman in the ecumenical movement, S. C. Leung, published in *Venite Adoremus II: Prayers and Services for Students*, World Student Christian Federation, Geneva, n.d., p. 192. Reprinted by permission.

p. 48 (facing plate XXIV):
Meditation based on John 20:19, 21, by M. M. Thomas, *The Realization of the Cross*, Christian Literature Society, Madras, 1972, p. 47. Reprinted by permission.

p. 50 (facing plate XXV):
Summary of the Korean poem "The Six Bullet Pistol Worship" by Kim Chi Ha on the basis of a free translation into English by Park San Yung.

p. 54 (facing plate XXVII):
Excerpts from the liturgy of the Ethiopian Church. English translation from Peter D. Day, *op. cit.*, pp. 115, 141 and 151. Reprinted by permission.

p. 56 (facing plate XXVIII):
Excerpts from the Meditation on "The Redeemer's Tree", in John S. Mbiti, *The Voice of Nine Bible Trees*, Uganda Church Press, Mukono, 1972, pp. 20 and 22. Reprinted by permission.

p. 58 (facing plate XXIX):
Hymn written in 1965 by the West African Abel Nkuinji, to be sung to a traditional melody from the Cameroun. Translation of the original French version by Eric Routley. Published in *Cantate Domino: an Ecumenical Hymn Book*, Bärenreiter Verlag, Kassel, 1974, No. 86. Reprinted by permission.

p. 62 (facing plate XXXI):
Unpublished meditation written by Engelbert Mveng, SJ, in relation to his apsis painting in the Libermann College at Douala, Cameroun.

p. 64 (facing plate XXXII):
Closing paragraph from "Dear Friends": short address by Philip Potter to the members of the Central Committee of the World Council of Churches, meeting in Utrecht, August 1972, on the occasion of his election as general secretary of the Council. Published in *The Ecumenical Review*, XXIV/4 (October 1972), pp. 471–473.

p. 69
Quotation from Paul Klee, *Tagebücher*, Cologne, 1959, p. 378 (July 1917), and *Schöpferische Konfession*, ch. I, Berlin, 1920. English translation in Nello Ponente, *Klee*, A. Skira, Geneva, 1960, pp. 55 and 56. Reprinted by permission.

p. 70
Translated from Cyril, in Migne, *Patrologia Graeca* 33, 805 B.

p. 70
Translated from Cicero, *Pro C. Rabirio perduellonis reo*, 5, 16.

p. 71
Quotation from Flavius Josephus, in *De Bello Judaico* V, 449–451. English translation by H. St J. Thackeray in The Loeb Classical Library, *Josephus III*, Harvard University Press: William Heinemann, Cambridge, 1961, p. 341. Reprinted by permission.

p. 77
The sentence from Blaise Pascal is quoted from his essay "Le Mystère de Jésus" (1655?). English translation in E. Cailliet and J. C. Blankenagel, *Great Shorter Works of Pascal*, Westminister Press, Philadelphia, 1948, p. 134. Reprinted by permission.

p. 79
From third stance of the song "Una cruz de luz" by Daniel Viglietti, unpublished. Spanish text provided by James E. Goff, Lima.

p. 81
The Javanese *guru's* explanation of the painted crucifixion relief was secured with the help of Drs B. Drewes, Yogyakarta.

p. 83
The poem by Gabriel Setiloane was published by Th. Wieser (ed.), *Salvation Today and Contemporary Experience*, WCC, Geneva, 1972, pp. 32–34.

p. 84
Quoted from the report of an exploratory consultation for the Faith and Order study on "Giving Account of the Hope that is in Us" (Bangkok, January 1973), in *Study Encounter* IX/3 (1973), pp. 3f.

List of Plates

Plate I
"The cross of transfiguration." Apsis mosaic of Sant'Apollinare de Classe, Ravenna (6th century). Published by permission of the Soprintendenza per i beni ambientali e architettoni delle provincie di Ravenna, Forli e Ferrara, Italy. (Detail)

Plate II
(a) Ivory tablet on the crucifixion from northern Italy (A.D. 420–430). The British Museum, London, England. Published by permission of the Museum's Trustees.
(b) Crucifixion scene on the wooden doors of Santa Sabina, Rome (around 432). Photo Anderson. Published by permission.

Plate III
Crucifixion and resurrection scene, illustration in Codex Rabula, fol 13r, from Zagbar, East Syria (A.D. 586). Bibliotheca Medicea-Laurenziana, Florence, Italy. Photograph by Guido Sansoni, published by permission of the Bibliotheca.

Plate IV
Carolingian ivory relief with crucifixion, cover of pericope-book of Henry II (9th century). Bayrische Staatsbibliothek, Munich, Federal Republic of Germany (cod. lat. 4452/Cim 57). Published by permission of the library's department of manuscripts.

Plate V
Frankish gravestone from Moselkern near Cochem, Germany (7th century). Rheinisches Landesmuseum, Bonn, Federal Republic of Germany, Inv. Nr. 27679. Published by permission of the museum's photo archives.

Plate VI
Gero-Cross in the Cathedral of Cologne, oakwood sculpture (around 965). Published by permission of Rheinisches Bildarchiv und Erzbischöfliches Diözesan-Museum, Cologne, Federal Republic of Germany.

Plate VII
Icon of crucifixion, school of Master Dionisi, Moscow (around 1500). Tretiakov Gallery, Moscow. Published by permission of the Gallery and the Copyright Agency of the USSR.

Plate VIII
Catalan crucified Christ of Romanesque period. Museo de Arte de Cataluna, Barcelona, Spain. Published by permission.

Plate IX
"The Devout Christ of Perpignan", Gothic wood sculpture, Chapel of St John the Baptist Cathedral in Perpignan, France. Published by permission of the Cathedral's Archpriest.

Plate X
"The Passion of Jesus Christ", painting by the Flemish artist Hans Memling (1470). Galleria Sabauda, Turin. Published by permission of the Soprintendenza alle Gallerie ed alle Opere d'Arte del Piemonte and Giustino Rampazzi, Turin, Italy. (Detail)

Plate XI
"Crucifixion", painting by Diego Velazquez (1631–32). Museo del Prado, Madrid, Spain. Published by permission of the Museo's Servicio de Fotografías y Publicaciones.

Plate XII
"The Three Crosses", 4th version of an etching by Rembrandt (1653). Copy conserved in the Metropolitan Museum of Art, New York, USA. Gift of Felix M. Wartburg and his family, 1941. Published by the Museum's permission. (Detail)

Plate XIII
"The Yellow Christ", painting by Paul Gauguin (1889). At present in the Albright–Knox Art Gallery, Buffalo, New York, USA. Published by the Gallery's permission (General Purchase Funds).

Plate XIV
"Crucifixion No 2", painting by the North American artist William Congdon (1960). Galleria Pro Civitate Christiana, Assisi, Italy. Published by permission.

Plate XV
"The Crucified in the Asphalt-Jungle", serigraph by the Swiss artist Paul Le Grand (1973). Private collection, Geneva, Switzerland. Published by permission of the artist.

Plate XVI
Crucifix made of maize pasta before a painting with St Franciscus and St Dominicus above scenes of the hell. Unknown Mexican artist of the 16th century. In the Church of St Francis in La Antigua, Guatemala. Published by permission of the photographer, Nancy E. Howard.

Plate XVII
"Crucifixion", painting by the Mexican artist Gonzalo Ceja (second half 20th century). Present location unknown. Published by permission of the International Christian Centre for the Arts, Mexico City, Mexico.

Plate XVIII
Crucifix in wood and clay by the Peruvian artist Edilberto Merida (second half 20th century). Photograph by Joseph Vail, M.M. Present location unknown. Published by permission of Orbis Books, Maryknoll, NY, USA.

Plate XIX
"The Power of the Powerless", drawing by the Mexican artist Rolando Zapata (1976). Private collection, Geneva, Switzerland. Published by permission of the artist.

Plate XX
"The Tortured Christ", sculpture by the Brazilian artist Guido Rocha (1975). Now in the All Africa Conference of Churches Training Centre, Nairobi. Published by permission of the artist and Photo Oikoumene, Geneva.

Plate XXI
Armenian *khatchkar* at Haghbat, Armenia (1272). Published by permission of His Holiness Vasken I, Catholicos of all Armenians, Etchmiadzin, USSR.

Plate XXII
"Descent from the Cross", painting by an unknown North Indian Muslim artist of the 16th–17th centuries. Private collection, India. Reproduced from the book by F. zu Löwenstein, *Christliche Bilder in altindischer Malerei*, Munster, 1958, by permission of the Aschendorffsche Verlagsbuchhandlung, Munster, Federal Republic of Germany.

Plate XXIII
"Calvary", painting by Wang Su-Ta (first half 20th century). Present location unknown. Copyright SVD. Photograph by H. Hammer, reproduced, with permission, from P. Bornemann, *Ars Sacra Pekinensis*, Verlag St. Gabriel, Mödling bei Wien, 1950.

Plate XXIV
Crucifixion batik by Bagong Kussudiardja, Yogyakarta, Indonesia (second half 20th century). Private collection, Geneva. Copyright H.-R. Weber.

Plate XXV
"Reconciliation", metal sculpture by Keiji Kosaka, Japan (second half 20th century). Present location unknown. Published by permission of *New World Outlook*.

Plate XXVI
Painted crucifixion relief by a Christian mystic *guru* (second half 20th century). On wall of a private house near Yogyakarta, Indonesia. Published by permission of the artist and the photographer. Copyright H.-R. Weber.

Plate XXVII
Painted illustration of crucifixion in St Arsima Manuscript, Ethiopia (14th–15th centuries). Photograph published by permission of UNESCO and the New York Graphic Society from the volume *Ethiopia: Illuminated Manuscripts*, UNESCO, 1961.

Plate XXVIII
Crucifix, wood sculpture by an unknown East African artist (second half 20th century). Presently located in the GABA-Institute, Kenya. Copyright H.-R. Weber.

Plate XXIX
Crucifixion scenes from a Via Crucis, wood relief by a Nigerian artist (second half 20th century). Photographs reproduced, with permission, from *Arte Africa e Christo*, Pro Civitate Christiana, Assisi, Italy, 1963.

94

Plate XXX
"Golgotha", painting by Gebre Kristos Desta, Ethiopia (1963). Private property of the artist and published with his permission.

Plate XXXI
Crucifixion fresco on the apse of the Chapel Libermann College in Douala, Cameroun, by the Cameroun artist Engelbert Mveng (second half 20th century). Published with his permission.

Plate XXXII
"Crucifix", wood sculpture by Samuel Wanjau, Kenya (1977), in the chapel of the Paa Ya Paa gallery near Nairobi. Published by permission of the gallery. Copyright H.-R. Weber.

Plate XXXIII
Ancient Christian baptistery from 5th or 6th century at Jalyssos, near the monastery Philerimos on the island of Rhodes. Copyright H.-R. Weber.